D0831065

REBECCA CAHILL ROOTS

# Brush Lettering

BATSFORD

# Your brush lettering shopping list

If you want to get cracking right away or you're buying this book as a gift, here are some of the basic tools you'll need for your modern brush-lettering practice.

- A black Tombow ABT Dual brush pen
- Pro Arte Masterstroke round paintbrush size 4
- A pad of layout paper or Rhodia dot pad
- HP Premium LaserJet printer paper
- A ruler
- A pot of Higgins Eternal black ink
- A good eraser (my favourite is the Faber-Castell Dust-Free)
- Washi tape or a clipboard to help you keep your paper and guidelines in place.

For Little R, my incredible inventor x

First published in the United Kingdom in 2019 by
Batsford
43 Great Ormond Street
London
WC1N 3HZ

An imprint of Pavilion Books Company Ltd

MIX
Paper from responsible sources
FSC® C016973
www.fsc.org

Copyright © Pavilion Books Company Ltd 2019
Text and illustrations copyright © Rebecca Cahill Roots 2019

Photography by Michael Wicks and Rebecca Cahill Roots. Author photograph on page 159 by Katherine Leedale (katherineleedale.com).

All rights reserved. No part of this publication may be copied, displayed, extracted, reproduced, utilised, stored in a retrieval system or transmitted in any form or by any means, electronic, mechanical or otherwise including but not limited to photocopying, recording, or scanning without the prior written permission of the publishers.

ISBN 978-1-84994-544-8

A CIP catalogue record for this book is available from the British Library.

10 9 8 7 6 5 4 3 2 1

Reproduction by Rival Colour Ltd, UK
Printed and bound by 1010 Printing International Ltd, China

# Contents

# Well hello there!

Thank you so much for choosing this book to help you to get to grips with brush lettering. Whether you've got a project in mind that you're working towards, or you just fancy starting a new hobby, I'm thrilled to be part of your creative journey.

I'm Rebecca, I'm a calligrapher and I run Betty Etiquette, a hand-lettering and design studio where I create lettering for logos, magazines and weddings along with my own stationery range. Since writing my first book, *Modern Lettering*, in 2016, hand lettering has become an incredibly popular hobby for people around the world, and it is now commonly used in advertising, stationery, clothing and interior design.

As I write this introduction I'm sitting in a café near my home in London, England. Around me I can see different styles of hand lettering used on the chalkboards, menus and coffee cups, all providing information with a friendly, handwritten vibe. I can also see everyone around me on their phones and laptops, hidden away in digital worlds, only looking up for the occasional coffee sip or daydream. But as we slowly increase the amount of time we are spending buried away in screens, I believe we're also lusting after tactile, handmade aesthetics that reconnect us with family, history and our culture.

People are shopping handmade more, seeking out personalized presents and taking time out of their busy lives to learn traditional skills, such as weaving, woodturning and hand lettering. As an advocate for putting pen to paper and all things handmade, I'm delighted that hand lettering is fashionable again. I hope this book steals you away from the screens in your life for a while to give you the chance to slow down and learn something new.

I've been fascinated with lettering from a young age, and from the moment my big sister let me try out her calligraphy set and her dreamy collection of rainbow-coloured inks, it's been a real obsession of mine. Over the last 10 years I have begun experimenting with bolder techniques including brush lettering. I touched on this lettering style in *Modern Lettering*, and thanks to your messages and requests since the book was published, I'm thrilled to now bring you a big beasty book of brush-lettering ideas.

This book will walk you through the techniques I've learnt on my brush-lettering journey so far, both through my own lettering practice and from seeing participants at my workshops get to grips with the process. I've also enlisted some pen pals – some fantastic lettering artists from around the world – to show you their work so that you can see just how versatile the lettering style is and how you, too, can add your own personality to your pieces.

So whatever has inspired you to pick up a brush pen or paintbrush, I hope this book fills you with ideas and that like me, you too discover an overriding passion to write on anything that will sit still long enough to let you!

Now I've introduced myself, let's get down to the good stuff…

*Rebecca* x

More
than kisses
letters
mingle souls

x

# What is brush lettering?

When I tell people what I do, they often ask what brush lettering is and if it is a type of calligraphy. So I thought I'd start by telling you a little more about this beautiful art form and why I fell in love with it.

The word *calligraphy* broadly means decorative handwriting or handwritten lettering. It describes the process of writing not just to get a message across or to provide information, but to display words in an imaginative, artistic form. It's something more magical than simple handwriting for function. It's the difference between a quick note on a park bench saying 'WET PAINT' and a carefully drawn message to announce the potential wet paint disaster with artistic shape and form.

Traditional Western calligraphy is created using a dip pen and nib and may conjure up images in your mind of the lettering at the bottom of a certificate or the quotes on the wall in a church or school. To create this type of lettering you use flat-edged, broad-edged or chisel-tipped nibs and follow specific

rules about the angle at which you hold your pen and the size of the letters you make in relation to each other. But over the last 15 years a new style of lettering has emerged called modern calligraphy, which is created with a pointed nib and ink. It's a free and joyful style of lettering with very few rules, and it can be used for everything from wedding stationery to logo design.

So how does brush lettering fit in with this lettering trend? Modern brush lettering, or brush calligraphy as it is often called, is similar to the style of popular modern calligraphy, but it is created using different tools. Modern brush lettering uses brush pens and brushes and ink to create beautiful letterforms that are playful and bold. In the same way that dip pen calligraphy has developed its own contemporary style, brush lettering has had a recent resurgence in interest and taken on a new and exciting role in today's media.

The use of brushes for lettering is not a new thing, however; it can be traced as far back as around 300BC to China, where an ink brush was found in the tomb of a Chu citizen. Whereas Western calligraphy focused primarily on nib and ink as handwriting developed, brush lettering has played an extremely important part in the history of Vietnam, Korea, Taiwan, China, Japan and other far eastern cultures.

Traditionally, brushes were made with animal hair, ranging from goat, pig or rabbit to the more exotic tiger hair, tied to a handle made from bamboo, or for the wealthy, gold, jade or ivory. To be able to write beautifully was held in extremely high regard: in China it was seen as one of the four great things a successful intellect should be able to do.

As with dip pen calligraphy, traditional brush calligraphy had its own strict set of rules to learn. A Chinese calligrapher would practise for many years to master the correct symbol form, stroke pattern, pressure and ink/water ratio to be regarded as a true lettering artist. But of equal importance was the spirit of the calligrapher, or *Yi* as it was called. *Yi* means 'intention or idea', and this was seen as vital for the calligrapher to bring the letters to life. I love this concept and recognize it in my work and that of

my workshop students: if your head and heart are fully engaged in your lettering, something magical happens that brings those simple pen or brush marks to life.

Although nib and ink led the way in establishing literacy in Western culture, we should not forget that brushes have been used for lettering in signwriting, religious documents and graphic design for hundreds of years. Modern brush lettering brings together the traditional methods and equipment of brush calligraphy with the decorative lettering styles of modern calligraphy made with a dip pen, and lettering artists are using brushes, inks, paints and the fantastic new brush pens that have appeared on the market over the last 15 years to create this vibrant new style. Modern brush lettering asks you to commit to the patience, calm and focus that traditional brush calligraphy requires, but like modern calligraphy, it allows you to play around with the letterforms to express your personality.

In this book we are going to learn how to use both brushes and brush pens to create dynamic lettering styles. We will be focusing on brush-script styles that connect in a cursive flow and I'll be introducing you to a few hand-lettering fonts that are created using single, unconnected letters. I want to help you find a way to master the pen or brush you choose, so that you can fall in love with this art form as I have, and to enable you to make beautiful projects to share your skills with others.

# WHY USE HAND LETTERING
# IN A DIGITAL WORLD?

If you've attended one of my workshops in the past you will have heard me bang on about this before, but I can't advocate enough for putting pen to paper in a world that is slowly becoming more and more digitally focused. It's so easy to get lost in social media and advertising images that are airbrushed, manipulated and tweaked to be picture-perfect. But why, you may ask, when our lives are busy enough and with thousands of brush-lettering digital fonts at our fingertips, should we bother to take the time to do it ourselves?

### REASON 1: **IT'S UNIQUE**

You're creating a limited edition work of art each time you write something. Even if you copy your work out extremely carefully again, it will be slightly different. Perhaps a curve of a letter is a little flatter, the length of a flourish is accidentally longer; however hard you try, there will be tiny differences. It makes each letter you write or every project you make a one-off: made by your hand, it can't be copied, and that's the reason I fell in love with hand lettering.

### REASON 2: **IT'S SPECIAL**

We have more communication tools than ever before, but there's still nothing quite like the feeling we get when we receive a handwritten card or gift. To know how much time someone has put into making it especially for us, and thinking of us as they do so, will always beat a WhatsApp message or digital Christmas card.

### REASON 3: **IT'S MINDFUL**

Brush-lettering practice can have a positive effect on your mental health. As with many art forms, the process of practising brush lettering forces you to focus your attention on the shapes you are making, enabling you to slow your thoughts down. Participants at my workshops

often talk about how they feel relaxed afterwards because they have put away their phones and allowed themselves to completely focus.

### REASON 4: **IT'S GOOD FOR THE MEMORY**

Research carried out by scientists at Princeton University and the University of California found that writing by hand is far more useful for retaining conceptual ideas and for the long-term memory of information. So using handwriting for your notes or journal actually helps you to better remember information than typing it into your phone or laptop.

### REASON 5: **IT'S FOR SHARING**

You are creating something that will not only make you happy as you do so, but that you can so easily share with friends and family. Unlike some hobbies, you can sneak brush lettering into your daily life at every opportunity. Whether it's creating a birthday card, writing out a tea or coffee preference list at work, or adding notes in a photo album, people will really appreciate the time and skill required to make beautiful lettering.

It's that final reason that is my personal number one for encouraging people to have a go at brush lettering, for the pleasure it brings to others. I love sending letters and parcels with brush lettering all over the packaging, as I know it will bring joy to the recipients. Even the fairly grumpy postman in my local post office always mentions the lettering when he's weighing the packages and carefully puts the labels to the side to avoid covering it. When asked by a client to write out a couple's wedding vows for their wall, or a special quote for a friend who is grieving, I always find it to be a complete privilege. A pen or brush really is a mighty tool and I can't wait to see how you are going to use yours.

# Getting started

So let me just get this out of my system before I start this chapter...
I hate the bit in craft books that tells you how to use them. It's your
book and you can use it in whatever way you like, thank you
please. If you're like me, you'll already be covered in ink, pen in
hand and on the first exercises, dipping back into the instructions
as you go. But I know others prefer to follow a book page by page
and build up to the exercises more slowly. So whether you're the
type that races ahead and then goes back for the details, or you're a
page-by-page learner, feel free to use this book in the way that
works best for you. Here's what we're going to work through
together so you can decide how you want to organize your learning.

First, in this chapter we are going to get to grips with the materials you are going to need for brush lettering. You might have a few bits lurking at home, or want to gather some more before we get started, but we'll begin with just the essentials and build up from there. Once we've set up our workspace and covered a few basics, such as how to hold your pen, we can get cracking in Chapter 2 on the basic strokes needed for all the styles shown in this book. Then in Chapters 3, 4 and 5, it's time to get practising to try out a range of different alphabet styles, and perhaps a selection of different pens or brushes.

A big part of conquering lettering practice is composition, so in Chapters 7 and 8 we will look at how to lay out your work. In Chapter 9 you'll find fantastic inspirational work by some of my favourite lettering artists from across the world, and this will be sure to encourage you to try out a few of the new techniques introduced in Chapter 10, and then, in Chapter 11, there's a bunch of project ideas for you to peek at to see how you can use your lettering to make gifts and items for your own home. Finally, in Chapter 12, I've collected together all the most commonly asked questions from my workshop participants to help you answer any queries you might have.

Each person that comes to my workshop approaches the exercises in different ways. There's no time by which you need to complete the book, or points for the number of sheets of paper you get through. Take it at your own speed and simply try to enjoy the process. After eight years of brush lettering, I'm still learning and experimenting each day. My hope is that this book will be the start of your love affair with brush lettering and that you'll keep it close at hand, to dip in and out of as and when you need a top up of ideas, or a reminder of technique.

The most important thing to remember is to be kind to yourself. If the practice exercises are getting frustrating, it's probably because you're just about to crack it. So hang on in there and when you hit a stumbling block, do what all good artists do when they come to a standstill: choose your vice of choice (mine is a sticky cinnamon bun and coffee) and have a well deserved break.

# MATERIALS

Brush lettering is a pretty low-cost, low-key skill to begin practising. Basically, all you need is a brush pen, or brush and ink, some paper and a bit of patience. In some ways this is brilliant as it means people from all social backgrounds can access it easily. But because we are all used to writing from a young age, it can be extremely frustrating to have to relearn how to use this equipment in a different way. So, at this point in the proceedings, I want you to give your clever head a little talking-to and remind it to be patient with you as you pick up your brush pen or brush. Better still, ask it to pretend you have never written before. Try to follow the instructions with the same curiosity as you did when you were a kid and you discovered that blowing back through a straw made bubbles in your drink.

With that in mind, please let me start by introducing you to a brush pen and a basic round-head paintbrush. We are going to be using the black version of each of these pens in the first section of the book, moving on to work with colour once we've cracked lettering basics, such as angles, pressure and flow. Although you might be really familiar with these two types of lettering tool, I'm just going to run through the basic parts as a reminder.

## BRUSH PENS

Over the last 15 years some fantastic brush pens have been
launched onto the market that have made it easier to create great
lettering without needing to use a brush and pot of ink. But there
are hundreds of different types of marker pens out there, so how
do you know if you are buying one suitable for brush lettering?
Many brush pens are marketed as such, so will be easy for you to
seek out. But some great pens we'll be having a look at in this
book were originally made for other things, such as animation or
fashion illustration. To help identify a pen suitable for brush
lettering, look for a tip that is the shape of a round-head
paintbrush with some flexibility in it.

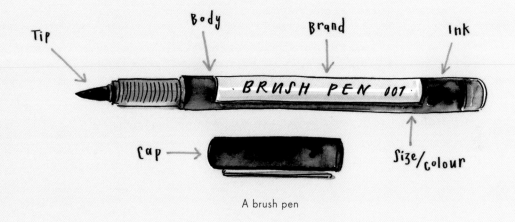

A brush pen

Each brush pen will vary greatly in the way it writes and how you
need to manipulate it to get the best out of it. Many of the best
brush pens were originally used for manga drawing so have a
natural flow and dynamic nature to them like a paintbrush. The
brush pen has four main characteristics that will affect the kind
of lettering you will be able to create with each one.

### 1. THE TYPE OF TIP

Most brush pens are made either with real hair from an animal or synthetic nylon hair, or from felt. The tips made from real or synthetic hairs are soft and will feel similar to using an actual paintbrush. They are smooth and very flexible, and take a little time to get used to. The felt-tipped brush pens are easier to control and harder to bend so feel more like a regular felt-tip pen, and these are the kind of pens I recommend for a beginner, as they are more forgiving when you're just getting started. But even with felt-tipped brush pens you need to watch out for the firmness of the tip.

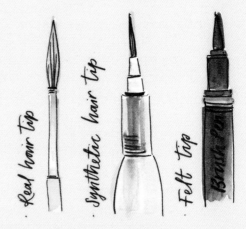

### 2. TIP FIRMNESS AND ELASTICITY

Some brush pen tips can be pressed firmly onto paper and hardly bend, while others are extremely soft and malleable as you place pressure on them. The tips with hairs are the most malleable and bounce back easily to their original shape after writing, whereas some of the felt-tipped pens are far more rigid and will lose their shape if you apply too much pressure or write with them for a long time.

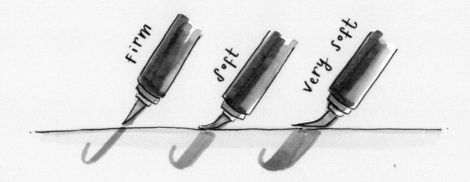

### 3. TIP THICKNESS

Depending on the type of project you are working on, you will need to think about the thickness of the pen tip you are using to make sure it is suitable. Some of the large-tip brush pens, such as the Ecoline pens, are brilliant for titles, large lettering quotes and gift tags. But they would not work to write the message on the back of a gift tag or in a birthday card as the pen nibs are too large and quite soft, allowing lots of ink out onto the page, making it hard to produce delicate work with this style of pen. If you wanted to write a long passage of text or something in a small area, you would need to pick a fine-tip brush pen.

### 4. THE FLOW

Most felt-tipped brush pens moderate the flow of the ink that goes through them. This means that as long as your pen still has sufficient ink in it to keep the tip wet, you can guarantee that you will have a consistent-sized stroke as you draw. This will prevent streaking in the lines you draw or getting ink blobs on your work as you write. The hair-tipped brush pens often require you to press the barrel of the pen to help release ink as you write. This can result in an inconsistent look to the strokes you're creating or a lack of clarity to the shape of your letters, and it will take longer to get your hand used to moderating the speed of the flow from them.

## PAINTBRUSHES

Brush pens are fantastic, but for me there is nothing quite like the delicious organic nature of a paintbrush dipped in ink or paint to create exciting lettering. No matter how many new brush pens I try, I still always end up gravitating back to my favourite old scrappy brush and my stash of inks when I'm trying out new ideas.

For the cursive brush-lettering styles we are learning in this book we need to use a round-head paintbrush. Although many traditional forms of signwriting and decorative lettering use a chisel-tip brush, we are bringing together the cursive alphabets of modern calligraphy with brushes, and so we need a round end to be able to create these fluid, flowing shapes. Here's a reminder of the parts of a brush.

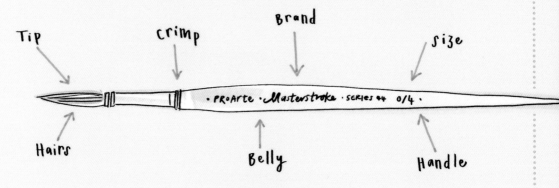

A round-head paintbrush

We'll be using the paintbrush in the same way as we will be using our brush pens, applying pressure to create thick downstrokes and using a delicate touch to make thin upstrokes. We'll be holding a paintbrush at a 90-degree angle to enable us to do this and using different inks to create graduation in tone and styles.

## ONE MORE INTRODUCTION

You've been introduced to the brush pen and the paintbrush, but there is just one final type of tool I'd like you to meet, and that is water (or aqua) brush pens and ink-filled hair-tip brush pens. Inside this style of pen there is a reservoir in the handle that can be filled with water or ink (the Pentel Black pens come with ink already inside). Here's a look at what a brush pen like this is made of:

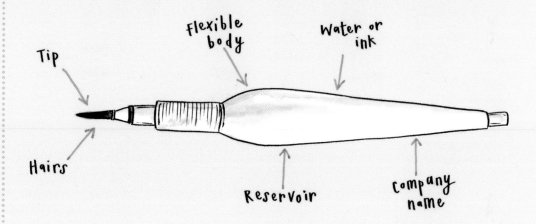

A water brush pen

These little wonders come everywhere with me as they can do so many different jobs, and with one of these in my pencil case I don't have to bring ink out with me for sketching. The water brush pens can be used for working directly in paints and for blending, and those with ink already inside create beautiful flowing lettering that has a unique and quite delicate look.

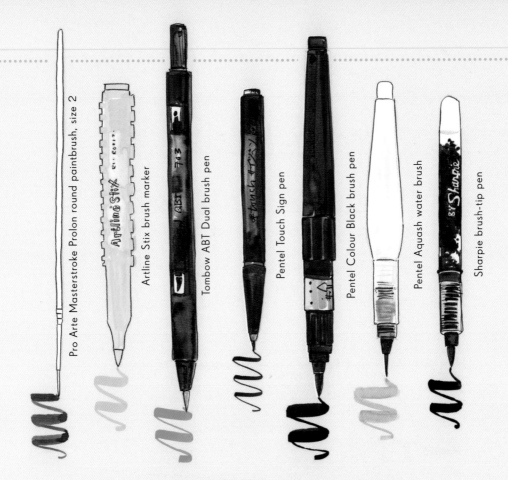

Pro Arte Masterstroke Prolon round paintbrush, size 2

Artline Stix brush marker

Tombow ABT Dual brush pen

Pentel Touch Sign pen

Pentel Colour Black brush pen

Pentel Aquash water brush

Sharpie brush-tip pen

## BEGINNER'S SHOPPING LIST

So what do you need to get started on your brush-lettering journey?

- A black Tombow ABT Dual brush pen
- Pro Arte Masterstroke Prolon round paintbrush, size 2
- A pad of layout paper or Rhodia dot pad
- HP Premium LaserJet printer paper
- A ruler
- A pot of Higgins Eternal black ink
- A good eraser (my favourite is the Faber-Castell Dust-Free)
- Washi tape or a clipboard to help you keep your paper and guidelines in place

We are going to be looking at a range of different brush pens and paintbrushes throughout the book, but for your beginner's toolkit I have picked a Tombow ABT Dual brush pen and a size 2 Pro Arte

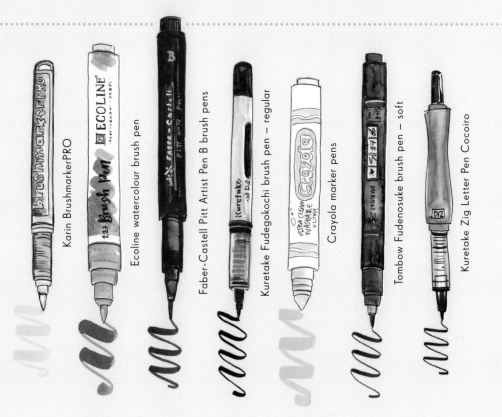

Karin BrushmarkerPRO

Ecoline watercolour brush pen

Faber-Castell Pitt Artist Pen B brush pens

Kuretake Fudegokochi brush pen – regular

Crayola marker pens

Tombow Fudenosuke brush pen – soft

Kuretake Zig Letter Pen Cocoiro

Masterstroke round paintbrush as your first two essentials. They are quite easy to source from shops or online (see Suppliers, page 158), but if you can't find a Pro Arte brush, another brand will do just as well, as long as it is a round-head brush and isn't any bigger than a size 5. Gather, borrow or buy the items above and you can use them as a base to try out all the exercises in this book.

In Chapter 6, Your Brush-lettering Shopping List, you'll find a much more detailed list for those of you who have become brush-lettering addicts in a short space of time, just like I did, and who want to invest in more materials to experiment with.

For the time being, here's a look at the other brush pens and brushes that are staples on my desk and that I've used for the hand-lettering samples in the forthcoming chapters. I've written some examples of lettering using each of the tools so you can see how different the same words can look just by choosing a different type of pen or brush. These are just a few of the hundreds of brush pens available, so do experiment to find the ones that work for you.

## PAPER

Getting used to lettering with brush pens and brushes can be tricky, but making sure you have the right paper can be a game-changer to your progress. The right paper and pen combo is vital to making sure you can concentrate on creating your letterforms, on pressure, shapes and transitions, without worrying about your work bleeding or smudging. Each pen or brush you try will behave slightly differently. Even if the pen size and tips look very similar, the consistency of the ink inside and the flow of it will mean one may be perfect for layout paper, and one may bleed straight through. So listed below are some paper recommendations for when you want to move on from your beginner's toolkit.

The very best way to find out if your pen works on a certain type of paper is for you to experiment with it. Run through a few of the mark-making exercises on a page and see what happens; try going over a few strokes two or three times to see how heavily you can layer up the pen on the paper before it becomes soggy and bleeds through to the other side. If you are writing in a journal, sketchbook or notebook, try out your pen on the back page first to check that it is not going to bleed through. As someone that has an unhealthy addiction to a fine-looking notebook or journal, I would hate you to ruin it with the wrong pen or brush.

There are some papers that are simply no good for brush lettering and are best to avoid for all your pens and brushwork. Porous paper, such as sugar paper, tissue paper and some Kraft paper, or handmade paper with lots of texture to it will make your ink bleed and feather badly as you write. Rough paper or

recycled paper can wear out your brush pen tips quickly and leave them with rough edges, so always look for paper with a smooth finish. Shiny surfaces like metallic cards or wrapping paper will also not absorb the ink, so it will take a long time to dry and may still smudge when touched.

The most important thing to look for in the paper or card you are buying is that it is smooth. This will help your pens and ink to flow easily across it without damaging the pens. The type of practice paper I use will depend on the markers and brushes I am working with. Here's a rough guide.

### FOR BASIC FELT-TIPPED BRUSH MARKERS
For example, Tombow ABT Dual, Crayola or Faber-Castell Pitt Artist Pen B:
• HP Premium LaserJet printer paper
• Daler-Rowney layout pad
• Rhodia dot pad
• Canson A4 marker pad

As you will go through hundreds of pages while you are learning, the most economical paper choice for regular brush pens is a high-quality LaserJet printer paper. Although it will cost more as an initial outlay, as you get 500 sheets per pack it is more cost-effective in the long run. This paper will be perfect for your drills (exercises for repeating the strokes again and again to get used to the flow and pressure). If you need something more transparent so you can see a guidelines sheet underneath more easily, use a pad of layout paper, but remember that as it is quite thin it won't support blending or large areas of colour without ink starting to seep through to the other side.

If you want to keep a pad in your bag to be able to practise on the go, then a Rhodia dot pad is a great idea. You can use the dots as guidelines for your work so you don't have to have a guideline sheet underneath, and the paper is thick and smooth, making it perfect for felt-tipped brush tips.

For example, Sharpie brush pens, Karin brush pens or Winsor & Newton brush markers:

- Cass Art Bristol paper pad
- Winsor & Newton Bleedproof paper pad
- Daler Rowney marker pad

If the pen you are using flows quickly, or has a very wide tip that creates big strokes with high water content, you will need paper with a bit more backbone than printer or layout paper. For these types of pen I use Bristol paper or marker paper that is smooth but also thick enough to hold the ink well. I have suggested a few brands here but most named brand versions in your local art store will work just fine. You may still be able to just about get away with using the beginner's toolkit LaserJet printer paper for some of these types of pen, so check before you invest in more expensive supplies.

### FOR PAINTBRUSHES AND BRUSH PENS WITH HAIR TIPS

For example, Kuretake brush pens, water brushes and any paintbrushes:

- HP Premium LaserJet printer paper
- Cass Art mixed media pad
- Daler Rowney cartridge paper

Although you will be using inks and paints for this style of brush lettering, you will not be wetting the paper heavily as you would do if you were painting a landscape or portrait, so there's no need to invest in watercolour paper for your practice work. Strong, smooth, mixed-media or cartridge paper will be fine, and as you get more confident in knowing how much ink or paint to apply to the paper, you may even be able to use the LaserJet paper for your practice without the ink pooling and bleeding through, so do experiment with this.

For example, wall art, birthday cards or place names:

- Tombow Bristol paper pad
- Daler-Rowney Bristol board pad 250gsm
- Hot-pressed watercolour paper 300gsm+

If you are creating something as a gift or to go on your wall, you will need paper or card that is going to last. Bristol board or a thick hot-pressed watercolour paper are my go-tos for this as they hold their shape well if folded and are perfect surfaces for both brush pens and most inks. Watercolour paper is vital if you are going to create a wash behind your work, or if you intend to use lots of thick lettering on your page.

### ENVELOPES

One super-easy but effective way of sharing your brush-lettering skills is to cover your envelopes with gorgeous lettering. If you're working on a mailing bag or padded envelope, most brush pens will work well; but if you are using regular C6 or DL envelopes, you'll need to check your pen on a sample envelope first. Many standard envelopes are thin and the lettering can bleed through to the other side, or onto your card or letter, if left inside. Most of the felt-tipped brush pens will be fine for the majority of envelopes, but I would avoid using the ink-filled markers or brush and ink on the envelope unless you have a spare one to try first. If you are hoping to address envelopes for a special occasion such as a wedding, head to Chapter 10, page 113 for some inspiration.

# SETTING UP YOUR WORKSPACE

To really get the best out of your practice, brush lettering should be done at a desk or table. Being hunched over on a sofa or bed will not only give you a pretty uncomfortable back, it won't allow you to move your arms in the correct way to create the letters properly on the page. So find a good spot at a table, make sure you're seated with your feet flat on the floor, and have enough room beside you to move your elbows freely. Brush lettering will require you to move your whole arm as you work, not just your wrist as you would do when handwriting. Try to adjust your seat so you are high enough to rest your arm gently on the table but not leaning over it so far that you are being supported by it. Make sure you have good lighting, especially if working at night, or in a dimly lit room.

When first starting out, it's a good idea to invest in a clipboard to work on. Although most brush pens will not seep through the paper, some of the inks and paints we will be using may go through the paper and mark the table. As you grow increasingly confident and know more about the consistency and flow of the ink, this will rarely happen, but while you are learning it's sensible to protect your work surface. (Alternatively, you could use some plastic sheeting to cover your desk.)

I find that music or a great podcast can help me to focus while I work, but I wouldn't recommend watching television as you practise as you need to really concentrate on learning the flow of each letter until it comes naturally and you no longer need to look at the examples.

# KEY LETTERING TERMS

We've all been writing since we were children so there are many terms I will use that may be familiar, but some may be new to you, so here's a run down of key typography and lettering vocabulary that you may come across as you learn.

**MAJUSCULE LETTERS** Large letters commonly known as uppercase or capital letters, the main feature of which is that they are all the same height.

**MINUSCULE LETTERS** Small letters commonly known as lowercase.

**LETTERFORM** The design and shape of a letter or character.

**DESCENDER** The part of a lowercase letter that extends below the main section of the other lowercase letters. For example, the tail on letters 'g', 'p' or 'q'.

**ASCENDER** The part of a tall lowercase letter that extends above the other lowercase letters. For example, letters 'd', 'h' or 't'.

**SERIF** The line that is used to finish off the main strokes of a letter. A clear example of this is the capital letter 'I', which could just be drawn as a vertical line, but is also commonly drawn with a fine serif line at top and bottom.

**SANS-SERIF** This describes lettering and typefaces that do not have the serif lines on them.

**CURSIVE** A style of writing in which all the characters are joined together.

**STROKE** A single pen or brush mark that when combined with other strokes makes up a letter.

**FLOURISH** An ornate loop or stylized extension to ascenders or descenders. These can be simply one extra turn of the pen as you start or finish a letter, or become extremely intricate and elaborate.

**GUIDELINES** A lined sheet that you can work directly onto or place underneath your paper to help keep your lettering consistent.

**INK BLEEDING** When the ink or paint is too wet for the paper to hold and it seeps through to the other side of the paper.

**INK FEATHERING** An unwanted reaction to using ink on low-quality or porous paper that creates tiny hair-like lines around your lettering as the ink seeps into the texture of the paper. It can be avoided by using the correct type of paper for the ink you are working with.

**BASE LINE** The line on which the bottom of most letters sit and the descenders extend from.

**NEGATIVE SPACE** The empty or open space around an object or word on a page; providing some breathing room around the words you create helps the eye to read and appreciate the image you've made.

**COMPOSITION** The art of bringing the shapes and letterforms together to create a layout that is pleasing to the eye and easy to read.

# HOW TO BECOME A
# LETTERING DETECTIVE

As you gain confidence with your work, you can seek out inspiration
from other lettering artists to decide what your favourite lettering styles
are. To understand what it is about a sample of lettering you really
like, you need to investigate the make-up of the letters to see how the
artist has created them, so prepare to go fully Jessica Fletcher or a
little Hercule Poirot to become a lettering detective. To help you do
this, I've drawn an example below and labelled the lettering anatomy
so you can see how many different elements you can adjust and change
to truly find your own unique lettering style.

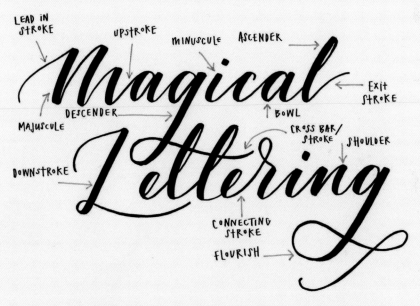

As you work through the exercises in the book, begin to think about
which lettering styles you like and why you like them. What makes
them different? Do they have extended descenders and ascenders?
Are they cursive or single unconnected letters? Is the height of the
cross stroke different? Investigate what it is about the design of the
letters that interests you. This will help you to understand what is
working and what is going wrong in your own brush-lettering practice.

# HOW TO HOLD YOUR PEN OR BRUSH

It's possible that you are going to think that I'm a complete plum for trying to tell you how to hold your pen or brush to write, but learning how to hold your pen correctly is key to making sure you can master the brush-lettering technique, and there are a few things you need to review.

### GET THE ANGLE RIGHT

If you hold a brush pen at the same angle you'd normally use to write a shopping list, you will find that you are fighting against the tip of the pen and you'll end up creating something that looks like you wrote it after a gin or two. If you turn your brush pen to a 90-degree angle in line with the top of the paper, it will allow you to create both the thick downstrokes and the thin upstrokes needed for the brush-lettering style. For most of you this is going to feel really strange and your pen will keep slipping back to the way you normally hold your writing pen.

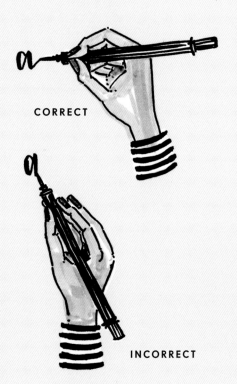

**CORRECT**

**INCORRECT**

Learning to write with your pen at the correct angle, as shown above, is going to be a game-changer for your brush lettering. Whether you draw a picture of a pen at the right angle on the top of your page, or you get someone to yell '90 degrees' at you every 15 minutes, getting used to holding your pen like this is going to be your first challenge.

### GET THE HOLD RIGHT

Everybody holds their pen in a slightly different way, which doesn't really matter if you are using a biro, but to get the best out of a brush pen or paintbrush for lettering, you might need to modify your style a little. Try to hold your pen or brush a couple of centimetres (around an inch) away from the place where the tip or hairs meet the barrel. If you hold it much closer than this you will get covered in ink as you write and it will be harder for you to change the pressure on the tip when you need to. If you hold it farther away, further up the barrel, you won't have enough control to master the thick downstrokes and thin upstrokes.

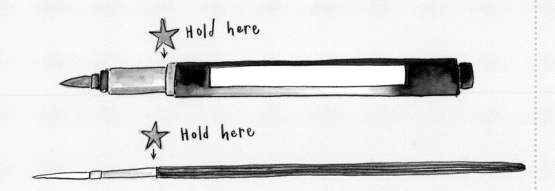

★ Hold here

★ Hold here

### GET THE GRIP RIGHT

Think about how tightly you hold your writing pen: if you normally hold it with a firm grip, you may need to try to loosen your grip slightly on a brush pen or paintbrush. Many people who come to my workshops find that they get cramp in their hands around 45 minutes into the session. This is because, for most people, the hand muscles are simply unused to long periods of handwriting. The more you practise, the more your hand muscles will get used to the movement and you will be able to work for longer without cramps.

# LEFT-HANDED
# BRUSH LETTERING

In every workshop I teach, before we even start, I know that around 10 per cent of participants are being doubly fabulous just sitting there. These are my brilliant left-handers who have come to learn brush lettering even though many of them tell me that their handwriting journey so far has been less than smooth.

The first thing I want to be clear on is this: brush lettering is for everyone, not just for right-handers. It is a decorative art form that can be mastered by both right- and left-handers. I am always delighted when left-handers come to a workshop and that they haven't been put off by past experiences with grumpy teachers or unsupportive friends. The reason left-handers will find brush lettering slightly trickier than right-handers is because the letterforms are based on calligraphy styles that lean off towards the right at a 55-degree angle, which, for left-handers, is generally working against the way in which their hand naturally wants to create the shapes.

When I'm trying to show a left-hander how to hold their pen I'm useless at reversing the process in my head and my writing comes out all over the place, so I'm completely in awe of lefties who are constantly finding ways to adjust to right-handed materials and tools. There are some tips that I have learnt from my left-handed workshop participants and from my left-handed

sister that I can share with you, but I have also noticed that each left-hander is different, so while some of these may work for you, the very best thing you can do is experiment. There's no bad mark you can put on a piece of paper while you're learning, so have a read of the instructions for right-handers, then play around with the tips below to see what works for you.

## UNDERWRITERS

If you hold your pen in the same way as a right-handed person, which is below the words you are writing, you're an underwriter and most of the right-handed instructions may work for you. Try to hold your pen in line with the top of the paper and pull it down to create a thick stroke and up for a thin stroke. You may find it hard to create the thin upstrokes this way as you will be going against the way the brush tip wants to go, so here are some ideas that I have seen work for underwriters:

- Play around with the angle of your paper to see if holding it at another angle helps to make the upstrokes easier.
- Use a less flexible brush pen, such as a Tombow Fudenosuke fine-tip, as this will make it easier to transition between the thick downstroke and thin upstroke.
- Separate out the strokes of each letter instead of trying to do them all in a cursive movement. For example, to draw a lowercase 'd', make the thick downstroke, then take your pen off the paper and bring your pen to the centre of the downstroke and begin the curved stroke there.
- You may even find it easier to do all your lines as downstrokes and simply moderate the thickness with the pressure you are applying.
- Try rotating your hand slightly up so your hand is covering the letters as you write; this may help you to have enough control to nail those upstrokes with practice.
- Use brush pens that dry quickly and scrap pieces of paper to cover the work you have already done to help to prevent smudging, and to stop you from getting your hand covered in ink.

## OVERWRITERS

If you curl your hand right over your work as you write, you are an overwriter. Trying to copy the way in which a right-hander learns brush lettering is never going to work for you, so let's try to take charge of it in other ways:

- To create thick strokes reverse the process and pull the pen up, not down, applying pressure as you do so, then the thin upstrokes will become downstrokes as you push your pen towards your chest with very light pressure.
- Try re-orientating your page by 90 degrees and write the words down the paper towards you.
- Pick the brush-lettering styles that are written with a vertical downstroke rather than on an angle – these will be easier for you to get to grips with as you are not pushing against the tip to create the upstroke.
- Pick a brush pen with a smaller nib, such as a Kuretake Fudegokochi brush pen in a regular size.

Brush pens can be quite liberating for people who write with their left hand as these pens have lots of flexibility and don't have to hit the paper at a specific angle like a nib- or chisel-tip lettering pen has to. Because of this, with a little experimentation and lots of practice, you can find the angle that works for you to help you to achieve your own unique style. As with anyone trying brush lettering for the first time, don't be defeated after your first few tries. It really is like learning how to bake. There will be the equivalent of many pies with soggy bottoms and cakes that don't rise before you make a truly smashing Victoria sponge.

# GUIDELINES

When I work I always try to have my paper straight on in front of me to help me with my composition and spacing. For underwriters, overwriters and all those in between, spacing your letters correctly may be challenging when you first start out as you may be working at an angle or tilting your paper. Until you become more confident, a pencil and ruler will be your best friends. Don't be afraid to mark out your letter spacing in pencil first to give yourself the chance to concentrate on the shapes of the strokes as you are writing.

### HOW TO USE GUIDELINES FOR YOUR WORK

When you are first starting to learn brush lettering, guidelines are a fantastic way to help find consistency in your basic strokes and shapes. You can draw guidelines in pencil directly onto your paper, or to save yourself some time, you can make yourself a master set that you can place under your practice sheets each time. Guidelines can help you not only to keep your letters straight across the page, but to ensure the angle of your letters is consistent in your work too. Simple, straight guidelines can be used for any style of lettering, and italic guidelines with slanted lines running diagonally across the page can be used for letterforms with a slight slant.

To get you started I have created A4 versions of large and fine pen guidelines and an italic guideline set. You can download these and print for free at www.bettyetiquette.co.uk. If you are printing these to work straight onto, make sure you print them onto some of the paper I recommend for your practice (see page 22), and if you are going to print master copies to put under your practice paper, use a stiff, smooth card to make them last longer.

In my studio I use a desktop light box to help me to see my guidelines underneath my work. If you enjoy brush lettering and want to carry on practising, a light box can be a great investment

to help you with your spacing and for final project work. Have a look at the extended brush-lettering shopping list (Chapter 6, page 92) for the ones I recommend.

So which line do you actually write on?

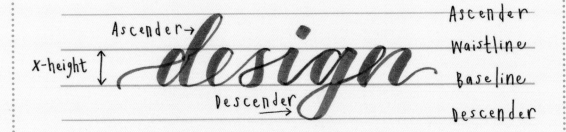

In this book I will be showing you both slanted and vertical styles of lettering that sit on the base line as in the examples here. In case you want to rule out your own guidelines in a sketchbook or for a project, the x-height of the basic guidelines is 15mm ($^5/_8$in) for large brush pens and paintbrushes and 7mm (just over $^1/_4$in) for fine-tip brush pens (the x-height is the height of the main shape of the letter, for example, the round section of a 'b' or a 'p').

There are lots of different guidelines out there for brush lettering and some are much more complex than the two examples I have provided, but at this stage I recommend that you keep it simple to concentrate on your grip, pressure and angles. But my real hope for you is that eventually you won't use guidelines at all, basic or otherwise, as you will be writing using different font styles that don't sit on the lines, on curves, and with pens that are yet to be made! But we all have to start somewhere and these guidelines will give you a foundation to get your letters consistent and help you to see how I have drawn them. If you don't want to use guidelines from the start, don't! It's totally up to you to develop your own way of working for your unique-look lettering style.

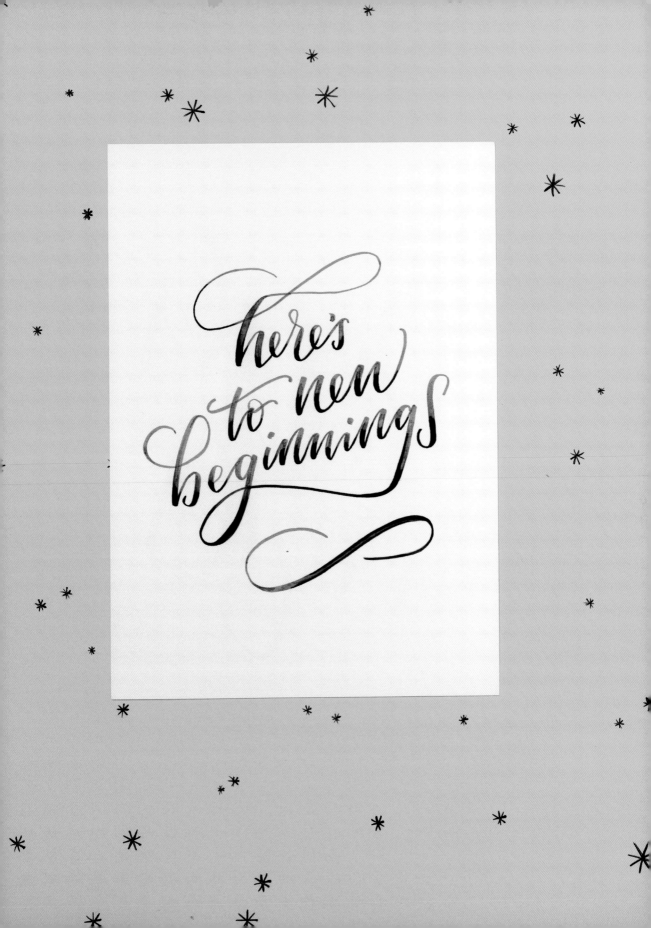

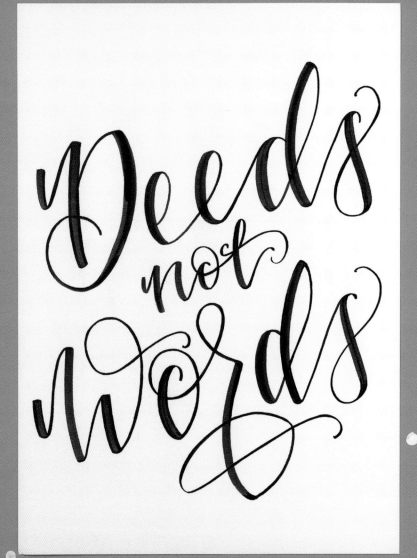

# The basic strokes

To create the letterforms shown in this book, there is a set of basic strokes to get to grips with first to help you form the letters correctly. They are a collection of straight and curved lines that make up the letters and require you to move your pen or brush in different ways to make them.

As a general rule, to create the brush-lettering aesthetic, all your downstrokes are thick lines and all your upstrokes are thin lines. You produce the difference in the size of line by adding pressure to the tip when you are pulling it down and applying no pressure when writing an upstroke. Here's what your pen nib will look like on the paper when you are creating the different strokes.

There's no better way to figure this out for yourself than to have a go, so grab your pad of paper and try out these first two strokes. You're looking for consistency, so as soon as you can make these shapes look the same, width and length, again and again, you can move on. For all these basic exercises I recommend a Tombow ABT Dual brush pen, but you can use any brush pen you have to hand.

Before you get started don't forget — MAKE SURE YOU'RE HOLDING YOUR PEN AT A 90-DEGREE ANGLE IN LINE WITH THE TOP OF THE PAPER!

Light Pressure

Heavy Pressure

Upstroke

Downstroke

# INTRODUCING THE
# BASIC STROKES

### DOWNSTROKE

This stroke will be the backbone of many of your letters and it needs to be a bold, strong movement. To achieve this, press down on the pen as you move it down and release it when you hit the base line. Have a go at around 40 of these and come back when you're done.

### UPSTROKE

Sometimes called an entrance stroke, this stroke is the one you use to start letters and connect them in a word. To make these you put hardly any pressure on the pen and let the tip do the work for you. Have a go at writing about 40 of these and I'll be right here when you get back.

### OVERTURN

Now you've got the downstroke and the upstroke looking pretty good, let's look at an overturn. This is the shape you will make when writing letters such as 'm', 'n' and 'h'. It brings together the thin upstroke and thick downstroke in one movement. Change the pressure on your pen just as you tip past the highest point of the shape. Try to make 20 or so consistent versions of this shape before moving on to the next exercise.

### UNDERTURN

This is the reverse of the overturn and will be used in letters such as 'u', 'v' and 'i'. This time you're starting with a thick downstroke and transitioning to a thin upstroke. Cracking the transition from thick to thin is key here, so take your time to practise at least 20 of these before moving on to the next stroke.

### LEFT CURVE

This stroke begins with a light upstroke before transitioning into a thick downstroke and back to thin. An important thing to watch out for here is

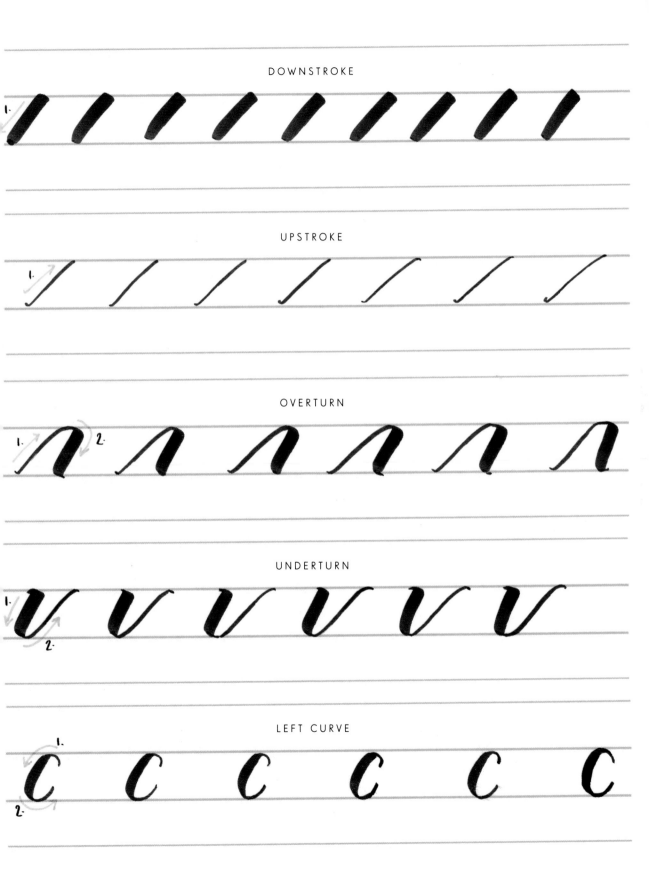

DOWNSTROKE

UPSTROKE

OVERTURN

UNDERTURN

LEFT CURVE

41

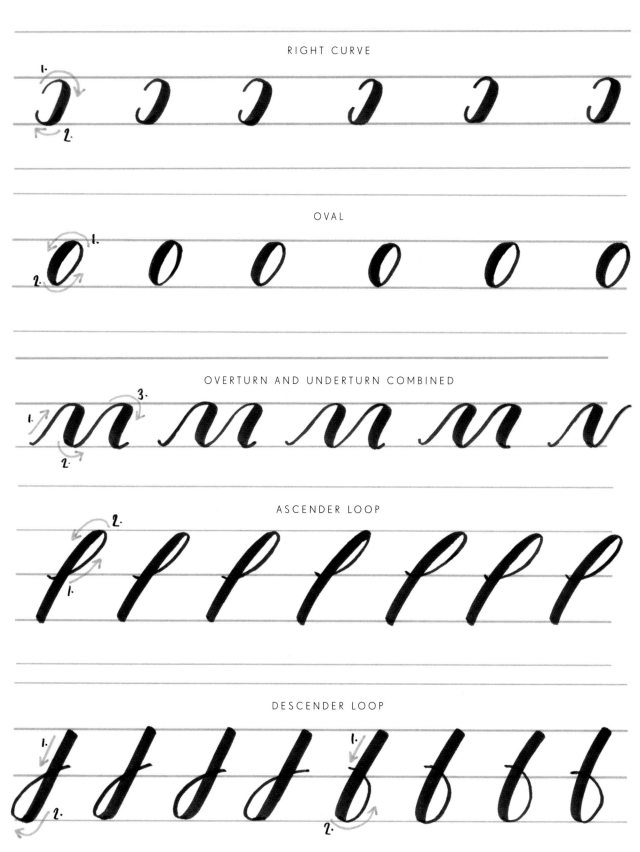

RIGHT CURVE

OVAL

OVERTURN AND UNDERTURN COMBINED

ASCENDER LOOP

DESCENDER LOOP

42

that your curve shapes do not have a flat top or bottom. To avoid this, start to change the pressure on your pens slightly before you think you should. This will help you to get ready for the change as you become accustomed to making the stroke.

### RIGHT CURVE

This is a mirror image of the left curve, so follow the same flow of thin upstroke to thick downstroke and back to thin.

### OVAL

This stroke is going to be used a lot to create many of your letters, so it's one you need to get right from the start. Begin your shape from the point marked with the number 1, not at the top of the shape: this will help you get a smooth shape where the lines match up with the same thickness.

### OVERTURN AND UNDERTURN COMBINED

This combination of the overturn and underturn stroke starts to really challenge you to change the pressure at the right stage in the shape. You also need to keep the strokes an equal distance apart and at the correct angle.

### ASCENDER LOOP

This is the shape you will use for letters such as 'l', 'f' and 't' that rise above the waistline to meet the ascender line. You will start with a fine upstroke then transition into a smooth, thick downstroke.

### DESCENDER LOOP

This is the shape you will use as part of letters such as 'g', 'j' and 'y'. It starts with lots of pressure on a thick downstroke before moving into a long, smooth, thin upstroke.

- **DRILLS**  To get used to these new strokes you need to start doing regular sets of drills, pages and pages of these same shapes over and over again until you are doing them without thinking. Although at times it might feel like a punishment, drills are essential to get your hand used to making these shapes.
- **MUSCLE MEMORY**  Think of this process as a workout for your hands. You need to teach the muscles in your hand to hold the pen in the right way and apply the pressure at the right time. Muscle memory is key to being able to create flowing movement for your lettering, leaving you free to think about the shapes you are creating. Although I wish I had a magic glove to give you that could speed this up, it will only come with practice, practice, practice.
- **SPEED**  I write three to four times slower when brush lettering than I do with a biro or fountain pen. You're making big bold shapes, not little letters, so slow down and give yourself a chance to really focus on the aesthetic of the shape you're making. Start to think of your lettering as a painting rather than a word, and enjoy the process.
- **KEEP AN EYE ON YOUR PEN**  If your pen slips back down to the angle you normally write with, you will find it almost impossible to replicate the example strokes I have given you. Keep your pen in line with the top of the page and make sure that you aren't gripping the pen too tightly.
- **DON'T FORGET**  You can find lots of answers to common questions and problems in Chapter 12, Troubleshooting, page 152.

## PRACTISING THE BASIC STROKES

Here is a selection of practice exercises using the basic strokes, and I use these to get my hand warmed up when trying out new materials. The best way to practise the basic strokes is to do several lines of each one before moving on to the next stroke.

# Luscious letters

Now you are a pro at the basic strokes, it's time to put them together for your first alphabet. I have created a basic minuscule and majuscule alphabet for you to learn as your first letterforms before we start to play around with lettering styles in Chapter 5. Unlike pointed pen calligraphy or your normal cursive handwriting, you can take your pen or brush off the page to start the next stroke. However, as I first learnt pointed pen calligraphy, I tend to try to keep my shapes flowing and I don't take my pen off until I run out of space and have to move my hand. I have broken down each letter into its strokes and shown you the directions to move your pen in. You can either work towards creating a letter in one movement, or stick to the separate strokes and add them together to form the letter; this will be something you can choose for yourself.

Some of the shapes of the letters may appear very different to the way you normally write them: this is so they have a cursive flow to the next letter. A good example of this is the letter 'r'. Some people write the letter 'r' like this (1) but the example I have given looks like this (2). I would love you to try to conquer these more complicated lettershapes and make cursive flow part of your style. But if this is putting you off, use a pencil to explore how you normally write these letters, then try it with a brush pen. You may not be able to find a way to connect your letters as easily, but you can make that part of your unique style and exaggerate it in your writing.

# MINUSCULE LETTERS

Work through the minuscule alphabet, writing out 30–40 of each
letter before moving on to the majuscule letters.

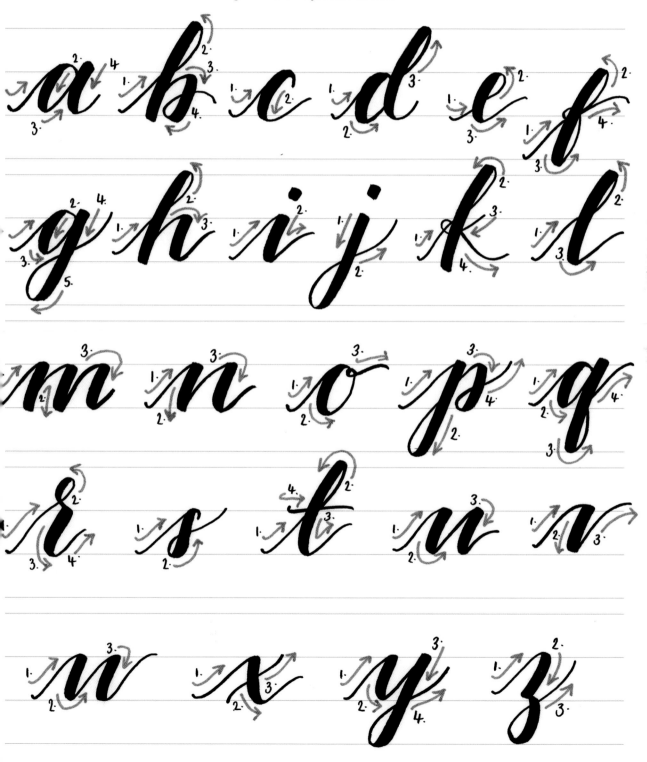

# MAJUSCULE LETTERS

Now try these glorious leading letters. Like the minuscule letters, they too are made up of thick down-strokes and thin upstrokes, but they are bolder and you will need to take your pen off the paper more.

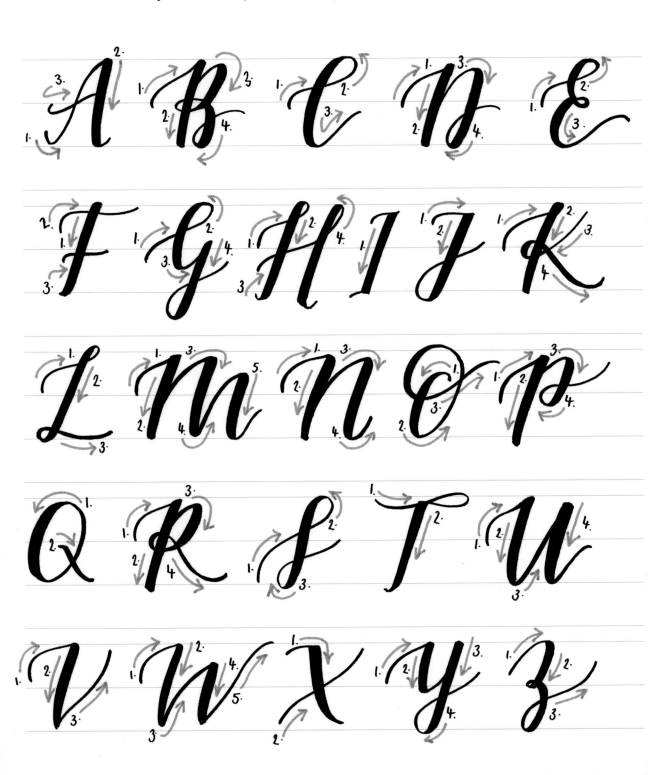

# NUMBERS AND PUNCTUATION

We're also going to need a basic set of numbers and punctuation to use in our lettering, so have a try at these shapes. Don't forget to keep a check on your pressure and the angle of your pen as you draw them.

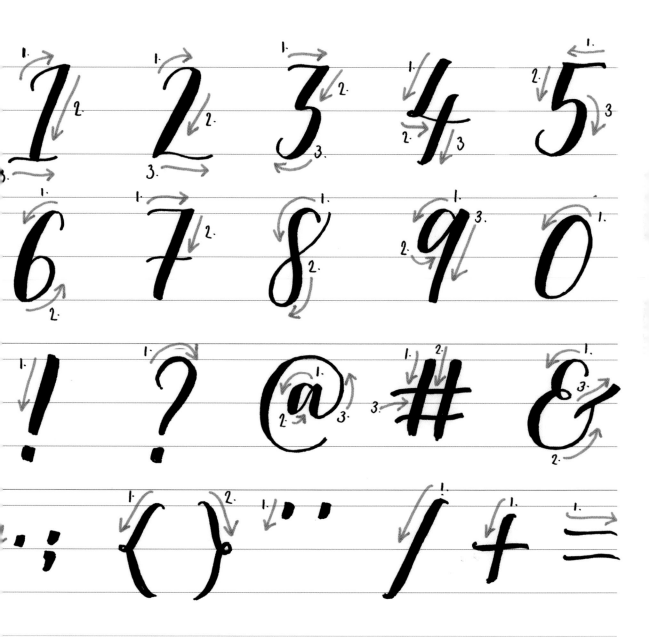

# CONNECTING LETTERS

This is where things get exciting and tricky all at the same time. Now you need to start to connect up your minuscule letters smoothly to be able to create words. To do this you are going to use that thin upstroke you have got so good at, both at the beginning of words and to run into the following letter.

Here's an example of the letters on their own.

*amazing*

And here's what they look like with the connecting strokes applied to them.

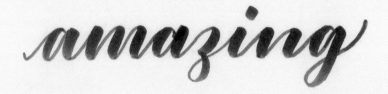

For some letters, you will have to adjust the height of the connecting stroke to ensure it flows. Here are a few examples:

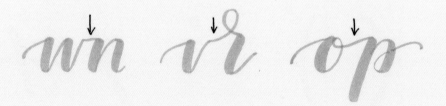

To get to grips with the flow of the connecting strokes, copy this alphabet a few times. If you are struggling with the connections while keeping your angle and pressure correct, try with a pencil first to get used to the flow before working with your pen or brush.

a b c d e f g

h i j k l m n

o p q r s t u v

w x y z

To start bringing the minuscule and majuscule letters together, it is a good idea to practise words you use every day so you can focus on the shapes of the letters rather than the spelling. Here are a few ideas to get you started:

Mum  Dad

Sister

Monday

Tuesday

Brother

Wednesday

Grandma

Thursday

Best friend

Friday

Husband

Saturday

Wife

Sunday

Baby

Birthday

With love

happy

joy

party

hooray    cake

you & me

coffee please

Well look at you being all marvellous and learning the basics of brush lettering. Now go and get some serious practice time in, and when you're ready, come back to have a go at some different lettering styles and materials in Chapters 5 and 6.

you can't use up creativity

# CHAPTER 5

# The mighty pen

The pen is mightier than the sword, or so they say, so now it's time to pick your weapon. In this chapter I'm going to share a bunch of brush-lettering alphabets with you that are created with different brush pens and brushes. The first thing you need to know is, you don't need to buy all these pens to write these alphabets. The shapes of the letters can be made with any pen of that size. So if you have only one brush pen right now, you can use this to try out any of these letterforms. However, I did want to show you the way in which a different pen or ink can create a whole new look for your lettering so you can start to think about what your signature brush-lettering look might be.

For each new brush pen or paintbrush I introduce, there is an alphabet, set of numbers, punctuation and some well-known phrases to practise with. On each page I tell you more about the pen and what it will feel like to use it. Some of the alphabets use slanted guidelines and some do not, depending on the angle of the letters.

If you get stuck along the way, head to Chapter 12, Troubleshooting, to see the most commonly asked questions in my workshops.

# ECOLINE WATERCOLOUR BRUSH PEN

This brush pen has a high concentration of liquid watercolour ink that produces a slightly transparent colour. It has a large tip that is quite soft and works the moment you touch it onto the paper. It can cover large areas quickly because of the big brush tip, so it's good for bolder lettering styles. It comes in a range of colours and can be mixed with water to produce watercolour-like blending when used on watercolour paper.

## LOWERCASE

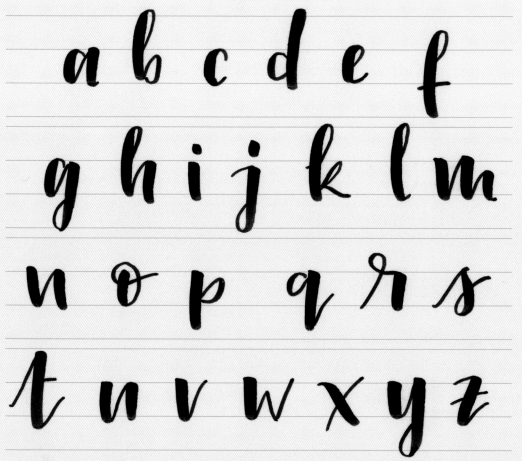

# Ecoline

A B C D E

F G H I J K

L M N O P

Q R S T U

V W X Y Z

1 2 3 4 5 6 7 8 9 0

# ARTLINE STIX BRUSH MARKER

At first glance this pen looks as if it is aimed at the children's market, but its soft, flexible nib is brilliant for lettering. They come in a range of colours and contain washable, non-toxic ink. They're very easy to hold, and because they have big broad tips, they are suitable for larger letterforms or bold titles.

LOWERCASE

a b c d e f

g h i j k l m

n o p q r s

t u v w x y z

# Artline Stix

A B C D E

F G H I J K

L M N O P

Q R S T U

V W X Y Z

1 2 3 4 5 6 7 8 9 0

# FABER-CASTELL PITT ARTIST PEN B BRUSH PEN

This pen has a much longer tip than some of the other brush pens in the large-tip group, which helps to create beautiful, flowing letters. The pigmented ink is water-resistant, permanent and light-fast, so it's a great pen to create finished projects with, such as greeting cards and wall art, as it won't fade. You may find this pen hard to use when first starting out as you have to rock your hand slightly to adjust the angle of the pen, but once you've got to grips with it, it can be one of the best for ornate script.

### LOWERCASE

a b c d e f
g h i j k l m
n o p q r s
t u v w x y z

# Faber-Castell

A B C D E

F G H I J K

L M N O P

Q R S T U

V W X Y Z

1 2 3 4 5 6 7 8 9 0

## SHARPIE BRUSH TIP PENS

Not to be mistaken for the regular Sharpie pen you might have lying around the house, the Sharpie Brush Tip Permanent Marker and Stained by Sharpie markers have a brush tip end. They will create both thick bold lines and thin delicate strokes with a soft, fluid tip. As they contain permanent ink, they can be used on a vast range of surfaces, and the Stained pen is a dedicated fabric brush pen. I mainly use them for finished projects and not for practice work but I really like the intensity of the ink.

### LOWERCASE

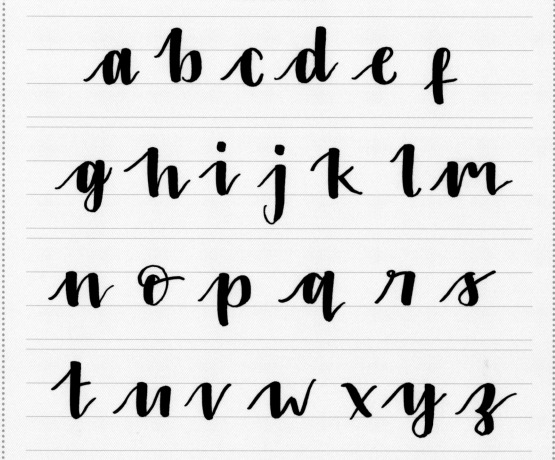

# Sharpie

A B C D E

F G H I J K

L M N O P

Q R S T U

V W X Y Z

NUMBERS

1 2 3 4 5 6 7 8 9 10

63

# KARIN BRUSHMARKERPRO BRUSH PEN

This super-bouncy, easy-to-use Japanese brush pen has a flexible nylon tip, perfect for brush-lettering script. The tip is quite large, however, so is only really suitable for bold titles or quotes. They come in a vast range of colours and can be blended. You can see the ink through the pen as you write and unlike some others, they keep the intensity of the ink colour right to the end of the life of the pen.

## LOWERCASE

a b c d e f
g h i j k l m
n o p q r s
t u v w x y z

# Karin

A B C D E

F G H I J K

L M N O P

Q R S T U

V W X Y Z

NUMBERS

1 2 3 4 5 6 7 8 9 0

# CRAYOLA MARKER PENS

If you haven't seen these pens for a while you might experience a rush of nostalgia when you get one in your hand. They were a childhood favourite of mine and I'd never thought of using them for lettering until I started to see examples on Pinterest and Instagram. As the tip of a Crayola marker pen is cone-shaped rather than a brush tip, you may find that you need to rock your hand slightly to make the thin upstrokes and thick downstrokes. It is better, therefore, to try these pens after you have first learnt the correct technique with purpose-made brush pens.

### LOWERCASE

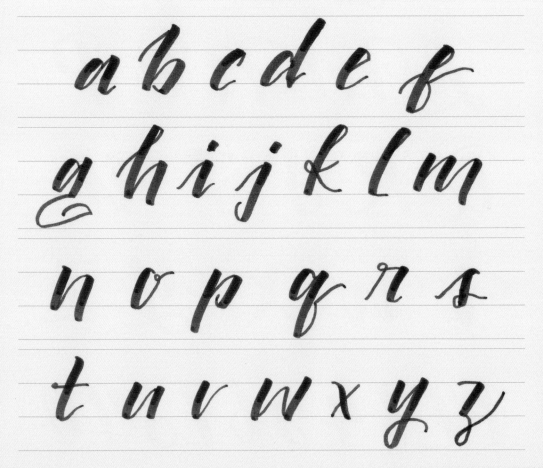

# Crayola

A B C D E

F G H I J K

L M N O P

Q R S T U

V W X Y Z

NUMBERS

1 2 3 4 5 6 7 8 9 0

# PENTEL TOUCH SIGN BRUSH PEN

This pen is great for finer lettering projects. It has a flexible fibre tip that can create letters small enough to use on birthday cards or correspondence. The water-based dye ink flows smoothly but it is easy to control. The tip is very elastic so with pressure you can make thick downstrokes and still have an extremely thin upstroke. Make sure that you pick the right one when buying these pens as they do look very similar to the Pentel Fude Sign fine liner pens.

## LOWERCASE

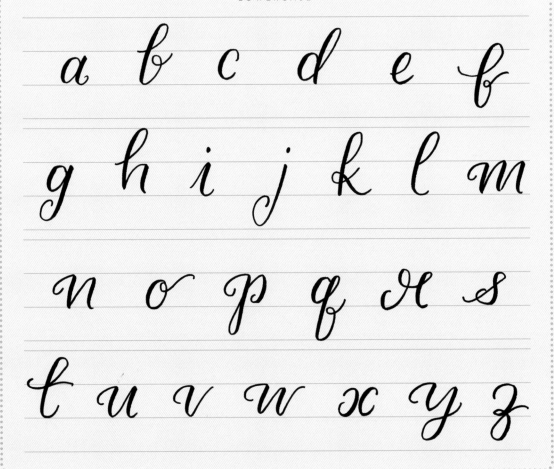

# Pentel Touch Sign

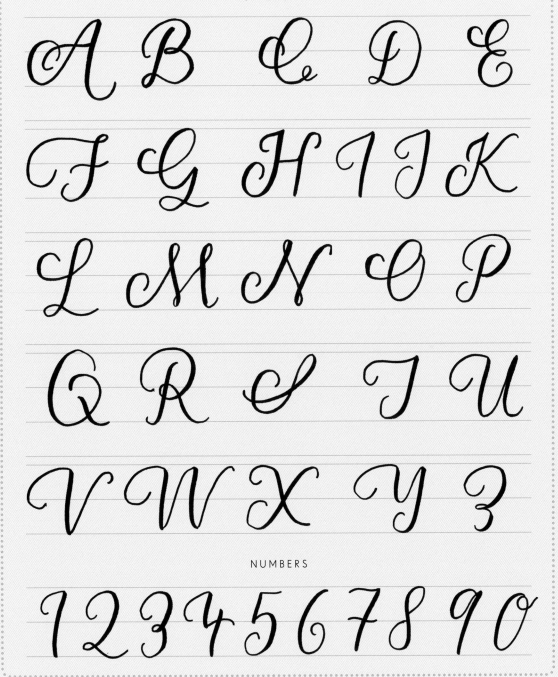

A B C D E
F G H I J K
L M N O P
Q R S T U
V W X Y Z

NUMBERS

1 2 3 4 5 6 7 8 9 0

# TOMBOW FUDENOSUKE BRUSH PEN – SOFT

This is the best buddy of the hard Tombow Fudenosuke brush pen but the tip is much softer and more elastic. It will create more fluid-looking lettering and is great for bullet journalling and small-scale lettering projects.

## LOWERCASE

a b c d e f
g h i j k l m
n o p q r s
t u v w x y z

# Tombow fudenosuke

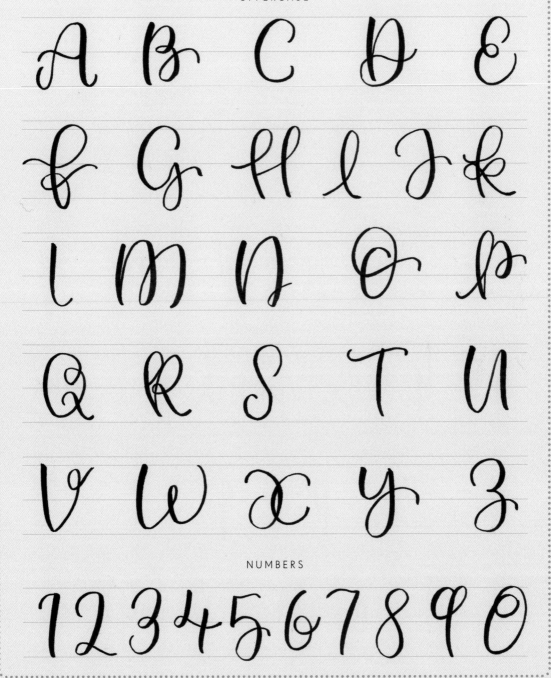

A B C D E
F G H I J K
L M N O P
Q R S T U
V W X Y Z

NUMBERS

1 2 3 4 5 6 7 8 9 0

# KURETAKE FUDEGOKOCHI
# BRUSH PEN – REGULAR

This was the first brush pen I ever tried so it will always be a favourite. It's a very smooth, soft-tipped pen that flexes well but retains enough rigidity to create lovely fine lines too. You can create quite large letterforms with ease but also smaller more delicate styles. I use it in my journal and for addressing day-to-day envelopes as it dries quickly with nice dark black ink. The ink is water-based so isn't permanent but sits well on top of other marker pens.

## LOWERCASE

a b c d e f

g h i j k l m

n o p q r s

t u v w x y z

# Kuretake Fudegokochi

A B C D E
F G H I J K
L M N O P
Q R S T U
V W X Y Z

## NUMBERS

1 2 3 4 5 6 7 8 9 0

# KURETAKE ZIG LETTER PEN COCOIRO

This pen is made up of two parts: the outside body section and a replaceable inner refill pen (I love that they have refills so that less plastic is going to waste when the pen has run out of ink). It comes in fine and extra-fine nib sizes, which are both useful for detailed work in small spaces, and the water-soluble dye ink gives a strong block colour. This is a really cute pen that you can chuck in your bag easily to sneak a little brush lettering in at work or college.

LOWERCASE

# Kuretake Zig Cocoiro

A B C D E

F G H I J K

L M N O P

Q R S T U

V W X Y Z

NUMBERS

1 2 3 4 5 6 7 8 9 0

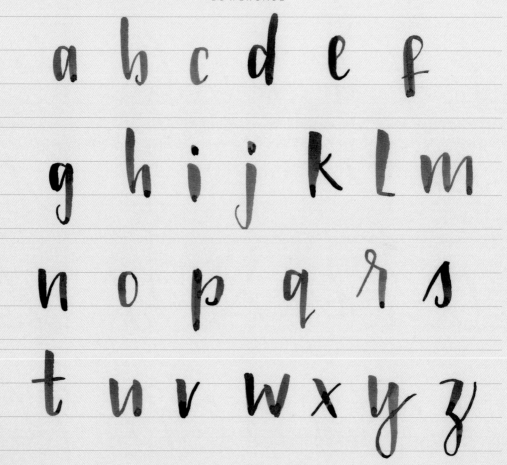

# PRO ARTE MASTERSTROKE PROLON ROUND PAINTBRUSH SIZE 2

I've used this brand for years for my illustration and lettering work. This is a great beginner's brush and it will last for a long time if you treat it right. This brush is made from synthetic fibres, which makes it very durable, but it will feel very different to using a brush pen for lettering; mastering the pressure needed to create the brush-lettering strokes will take time but it will be worth it. You can use ink, watercolour and gouache for brush lettering: I've used Higgins Eternal black ink here.

## LOWERCASE

# ProArte Brush

A B C D E

F G H I J K

L M N O P

Q R S T U

V W X Y Z

NUMBERS

1 2 3 4 5 6 7 8 9 0

# PENTEL AQUASH WATER BRUSH PEN

These are brilliant as they are so versatile. Fill the water reservoir in the barrel of the pen with water and use it to mix watercolours or gouache to work with directly, or fill it with ink and use it as a brush pen to get a really exciting effect with your lettering. It has a nylon tip and is available in four different sizes: fine, medium, broad and flat – you'll only need fine and medium for brush lettering. I have used Winsor & Newton black Indian ink and water in the barrel here.

## LOWERCASE

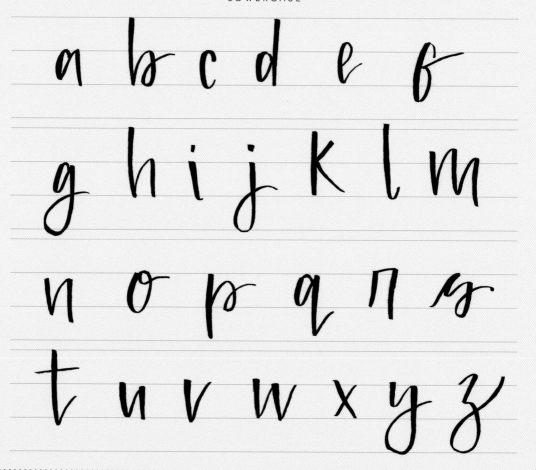

# Pentel Aquash

A B C D E

F G H I J K

L M N O P

Q R S T U

V W X Y Z

NUMBERS

1 2 3 4 5 6 7 8 9 0

# PENTEL BLACK BRUSH PEN

This brush is known for the textured strokes it creates and I use it when I want to have a more organic feel to the letters. The water-soluble dye-based ink is not light-fast but does come out thick and dark black. The tip is made of nylon hairs and so can be hard to control for beginners, and you need to be careful when placing the lid back on to avoid damaging the hairs. This pen has a big sister, the Pentel Colour Brush Pigment brush pen, which has permanent ink and is a bit more robust (see page 92).

## LOWERCASE

a b c d e f

g h i j k l m

n o p q r s

t u v w x y z

# Pentel Pigment

A B C D E

F G H I J

K L M N O P

Q R S T U

V W X Y Z

1 2 3 4 5 6 7 8 9 0

# PAINTBRUSH AND WATERCOLOUR PAINTS

If you have a tin of watercolour paints or some individual tubes you can use these for brush lettering. Mix up the paints with a little water and use your round-head brush to create a whimsical and flowing lettering style. When trying out this technique, it is best to use watercolour paper and don't forget to hold your brush at the 90-degree angle.

## LOWERCASE

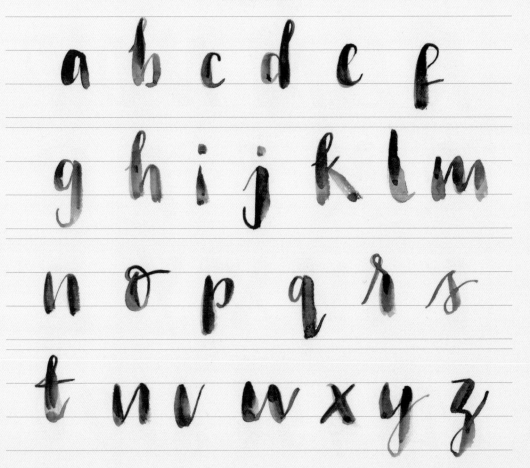

# Watercolour

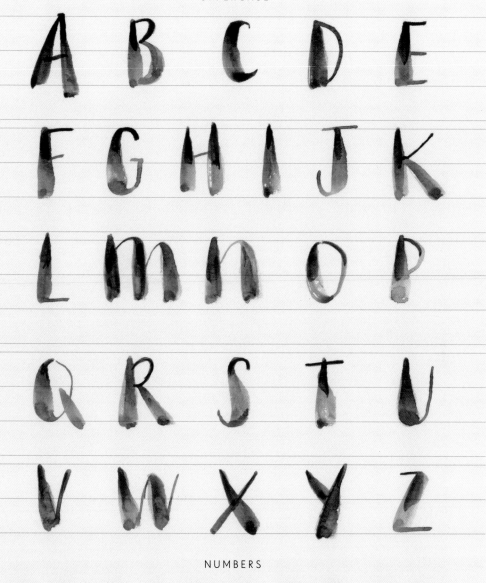

A B C D E

F G H I J K

L M N O P

Q R S T U

V W X Y Z

NUMBERS

1 2 3 4 5 6 7 8 9 0

# WATER BRUSH AND COLOURED INK

As water brush pens have a reservoir inside them, you can fill them with water and use it to mix with paint, or fill them with ink and work directly onto the paper. Here I have filled a fine-tip Pentel Aquash water brush pen with Ecoline magenta ink and worked directly onto the page. Watercolour paper or thick Bristol card is needed to make sure the paper doesn't get too wet and bleed.

## LOWERCASE

a b c d e f
g h i j k l m
n o p q r s
t u v w x y z

# Coloured Ink

A B C D E

F G H I J K

L M N O P

Q R S T U

V W X Y Z

1 2 3 4 5 6 7 8 9 0

# PAINTBRUSH AND GOUACHE PAINT

I use gouache regularly as I love the chalky opaque finish it creates. Gouache comes in tubes and you only need to use a small, pea-sized blob each time. You can thin it down with water and use white gouache to make pastel tones. It is much thicker than watercolour, so make sure you have watered it down enough to flow well from the brush. With gouache you get what you pay for, so I would recommend investing in Winsor & Newton Designers Gouache.

## LOWERCASE

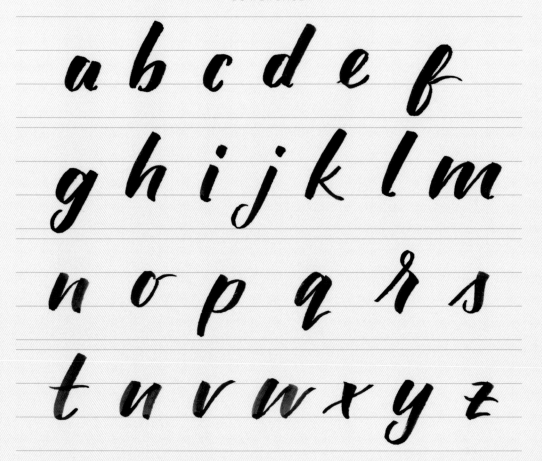

# Gouache

A B C D E

F G H I J K

L M N O P

Q R S T U

V W X Y Z

1 2 3 4 5 6 7 8 9 0

# FINDING YOUR OWN STYLE

The alphabets I've shared in this chapter are just the tip of the iceberg in terms of inspiration. Once you've started to define what styles you do and don't like, head to Pinterest and Instagram to look at other brush calligraphy alphabets. You'll discover that each hand-lettering artist will have their own alphabets, lettering quirks and favourite pens to use.

If you don't like the way I write my 'r', or want to vary the line width within a word, go for it! My greatest hope is that you start to write your own rules to really make your lettering unique. Then maybe one day you'll be messaging me to tell me about a new technique I should try. I'll look forward to that.

Here are some lettering elements you can experiment with to find your unique style.

### SPACING

Play with the distance between your letters to see how the shape of words changes as you add or take away the white space in between.

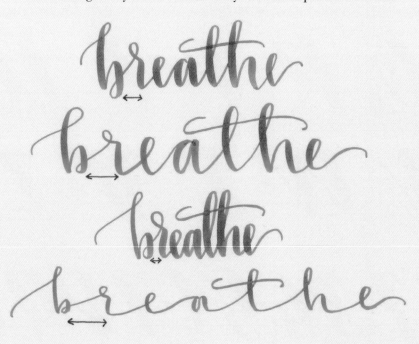

For this technique forget about trying to write all your letters on the base line; play around with the x-height; ignore the rules and let your lettering jump about on the lines.

Here's an example of some words written within the guidelines:

And here they are again, written using bounce lettering techniques:

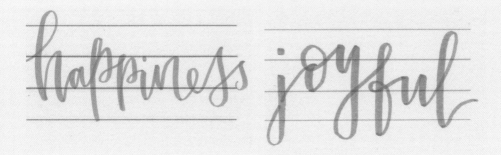

You can vary the height of your ascender and descender strokes, make your vowels small or large, change the base line as you travel through the word, and use your connecting strokes to make dramatic entrances and exits to the word.

EXAGGERATED ASCENDERS AND DESCENDERS.
With your letters all on the same base line, try extending the ascender
and descender strokes to see how this changes your lettering style.

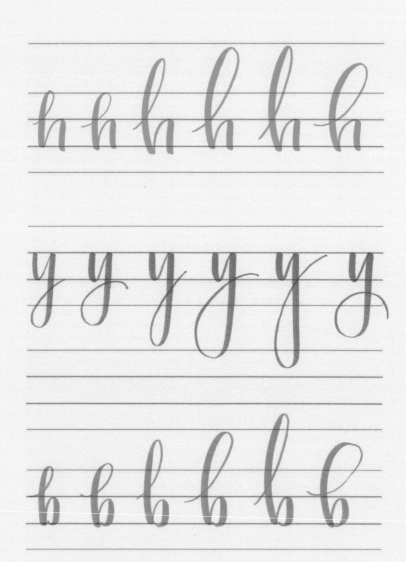

### CONNECTED AND DISCONNECTED LETTERS

Another way to make your lettering stand out is to decide when you might stop and start a word midway through it. You can connect some letters but leave others separate to create lovely balance and intrigue to the shape of the word.

Here is an example of a word that fully connected and then a version using unconnected sections.

*Serendipitous*

*Serendipitous*

*Serendipitous*

↑ ↑ ↑ ↑
S P A C E S

# Your brush lettering shopping list

So if you're having fun getting started and want to begin to build up a collection of materials to experiment with, here are some great brands that I would recommend.

## BRUSH PENS

### LARGE-TIP

- Tombow ABT Dual brush pen
- Ecoline watercolour brush pen
- Winsor & Newton brush marker
- Artline Stix brush marker
- Faber-Castell Pitt Artist Pen B brush pen
- Sharpie brush-tip permanent marker
- Karin BrushmarkerPRO brush pen
- Crayola marker pen
- Pentel Colour Brush Pigment brush pen
- Pentel black brush pen

### FINE-TIP

- Pentel Touch Sign pen
- Tombow Fudenosuke brush pen – hard and soft
- Kuretake Fudegokochi brush pen – regular
- Faber-Castell Pitt Artist Pen B brush pen
- Kuretake ZIG Letter Pen Cocoiro
- Arteza Sketch TwiMarker

## COLOURED BRUSH PENS

### LARGE-TIP

- Tombow ABT Dual brush pen
- Artline Stix
- Windsor & Newton brush marker
- Ecoline watercolour brush pen

### FINE-TIP

- Tombow Fudenosuke brush pen
- Pentel Touch Sign pen

**NOTE:** For white and metallic pens and inks, see Chapter 10, page 114.

## PAINTBRUSHES

- Pro Arte Masterstroke Prolon
  round paintbrush size 2 and size 4
- Pentel Colour Brush Pigment brush pen
- Pentel Aquash water brush pen –
  fine and medium
- Pentel black brush pen

## PAPER AND CARD

### PRACTICE PAPER
- HP Premium LaserJet printer paper
- Daler Rowney layout pad
- Rhodia dot pad
- Cass Art Bristol paper pad
- Winsor & Newton Bleedproof paper pad
- Daler-Rowney marker pad
- Canson A4 Marker Pad

### PROJECT PAPER
- Tombow Bristol paper pad
- Daler-Rowney Bristol board pad 250gsm
- Hot-pressed watercolour paper 300gsm+

### COLOURED PAPER AND CARD
- G.F. Smith Colorplan card 270gsm
- Daler-Rowney Canford Card 300gsm
- Creative Collection Premium card stock
  216gsm

### BLACK INKS
- Higgins Black Magic ink
- Higgins Eternal ink
- Kuretake Sumi ink
- Winsor & Newton Black Indian ink

## INKS AND PAINTS

### COLOURED INKS
- Winsor & Newton – non-permanent but
  can be worked over when dry
- Ecoline liquid watercolours –
  non-permanent and easy to blend
- Liquitex Inks – permanent and light-fast

### GOUACHE PAINT
- Winsor & Newton Designers Gouache tubes

### WATERCOLOURS
- Kuretake Gansai Tambi Japanese
  watercolour paints
- Winsor & Newton Cotman Water Colours
  half pan studio set

**NOTE:** For white and metallic pens and ink
see Chapter 10, page 114.

## OTHER THINGS

### PENCILS
- Faber-Castell 9000 basic art set
- Stabilio white pencil for film and glass

### ERASERS
- Faber-Castell Dust-Free eraser
- Tombow Mono Zero eraser pen

### LIGHT BOX
- MiniSun LightPad
- Daylight Wafer LED light box

### LASER LEVEL
- Black & Decker BDL220S

We are
such stuff
that dreams
are made
on

# Flourishing

Using flourishing in your lettering is like adding one of those little umbrellas to a delicious cocktail: it's not entirely necessary but it does look marvellous and it can make people smile. Flourishes can be extensions of the letters you are writing or they can be stand-alone decorations around your lettering and, when used correctly, they can add an opulent and magical quality to your work; but if done badly or used to excess, they can affect the legibility.

Although flourishes look extremely fun to do and can make your lettering look pretty fancy pants, I'm going to be really boring now and tell you to make sure you have cracked the pen hold, pressure and flow of brush lettering before you have a go at them. Flourishes are created with a gentle, looping movement of the hand as you enter or exit a letter. To ensure it looks like they are there on purpose, you need to be confident in your strokes before attempting them. That being said, if you feel you are ready to 'flourish', let's explore what you need to know.

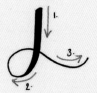

# FLOURISHING BASICS

As with lots of things in brush lettering, there are a few basic strokes to help you get used to the process, but then it is entirely up to your interpretation and style. There are no hard or fast rules as to which letters can or can't have flourishes; you make those decisions when laying out your design to help balance and improve your composition.

So let's have a look at the two strokes that make up basic flourishes in their most simple forms. These strokes go in two different directions to work with the flow of different letters. The first stroke is perfect for letters such as 'g', 'j', 'y' or 'z' as you continue on from the flow of the descender. Here's how they might look on some of those letters.

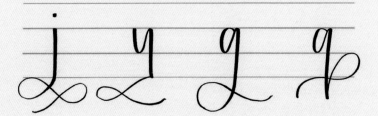

In these examples the movements travel forwards across the page, but you can also add flourishes to letters that travel backwards. Using the second stroke, try adding a flourish to letters such as 'm' and 'p', or add to an ascender, as shown here on the letter 'h'.

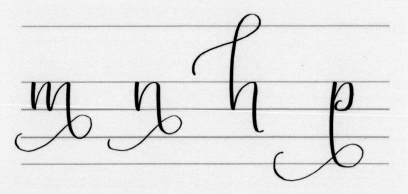

Adding a flourish to an ascender on a 'b', 'd', 'h' or 't' can help to animate the top section of your lettering. The flourish can travel forwards or backwards depending on the space you would like to fill. You can decide how big the loop will be, how far it will extend and how many turns of the pen there will be. These variations can take a flourish from a simple extension to something with lots of pizazz.

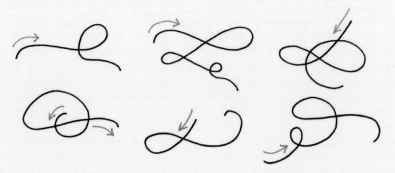

You can use flourishes to connect words above and below each other like this:

Flourishes can also be used to add an illustrative effect to your work. You can use them as page borders or as motifs carefully placed around your words for decoration. But remember, legibility is key so make sure that no matter how many flourishes you add, you can still read the word clearly.

A great way to get the hang of flourishes is to replicate other hand-lettering artists' work to see how they have made it: remember, this is for practice only and not for projects for sale – you've got your own great ideas to try out – so keep these experiments for your private sketchbooks. Take a browse of Pinterest, Instagram or YouTube to see how others are using flourishes and try some of these strokes on your designs.

# Composition

So you're getting the hang of this brush-lettering malarkey and starting to think about how you're going to cope with the fame of being a world-class lettering artist, but when you try to bring the words together for a quote or birthday message, they still don't look like a polished finished piece. So what is it that makes some brush-lettering projects look really magical while others look like they're never quite finished? Well it's a little thing called composition, and it's something that comes with a whole lot of practice and experimentation.

What you have to remember when you are designing a layout is that, although you are using words, you are creating a little work of art. Ask yourself: what is going to make it look balanced? How can the words fit together? How does the space around the words change the composition? Does it need any illustration or flourishes to support the design?

In this chapter, we are going to explore a few tips for getting to grips with composition to help you to turn your lettering into professional-looking work, but the best thing you can do to get better at it is to practise: get it wrong, get frustrated, try it again, and then make something marvellous.

## PICK UP A PENCIL
## AND GET SKETCHING

I start all my compositions with a pencil and scrap paper so I can work out roughly which word is going to go on each line. Although this won't give you a clear idea of how big the strokes will be with the pen you use, it helps get the creative juices flowing to decide where each word will go.

## EXPERIMENT WITH SHAPES

Another way of starting is to decide upon a shape and then experiment to see how your words are able to fit within it. For example, if your quote is about the sun and moon, you could draw two circles either next to or above one another, and try to fit the quote into them. If your circles are on top of each other, you could find ascenders and descenders that can move gracefully between them to connect the two circles. (A compass and a good metal ruler will help.)

To help with this process in my studio, I use a light box that I lay drawings of the guide shapes onto, then I place layout paper over the top and draw the lettering within those shapes. You could also sketch out a selection of shapes in a layout format to allow you to play around with which word will fit in each shape to create a dynamic design, and in Templates, page 156, I have provided some composition layout templates for you to trace and experiment with. A good exercise is to take one sentence and to try to lay it out in three different ways.

# NEGATIVE SPACE

Negative space in art is, simply put, the space around an object in a picture. It can be just as important to think about the space you are leaving blank as the letters you are drawing to help balance your composition. Often I see students at my workshops trying to make the design fill the whole page from top to bottom with the biggest letters possible. Although sometimes this will be a conscious choice to make a bold design, often it is a just gut reaction to getting started with brush-lettering composition. I love lashings of ink on the page so I have to fight this feeling every time I start a piece, but over years of practice I have learnt that carefully chosen areas of blank space around and within a composition can turn your lettering into something stunning.

If you are finding the words that you need to get on the page aren't looking balanced, no matter what configuration you are using, try adding some flourishes or illustrations in the gaps.

# BALANCE

Making sure your composition is balanced is really important as our brains are more receptive to a balanced image, so your work will look more pleasing to the eye if it has equal weight across the page. To do this, ensure that if you draw a big bold word in the top left, finish with one in the bottom right to balance it out. Or if you draw a big floral motif in the bottom left, make sure your lettering is focused in the top right to give the work balance. If you chose to centre your lettering in the middle of the page, make sure you have words that take up the same amount of space each side of your central line.

# IRREGULAR SHAPES

I'm often asked to create lettering for objects or card with irregular shapes. This might be a leaf, a shell or a card cut in the shape of a pineapple. If you need to letter in a shape like this, the best way to plan your composition is to sketch it out on paper first. You can either trace over the object if it is flat, or trace around the edge onto paper if it is not. Using this shape as a guide, experiment with where the centre of your work should be. You may decide that all the lettering should be focused in one area and the rest left to let the object tell the story, or that it needs big, bold lettering across the whole space. Try out a selection of different compositions before committing to ink or pen on your final object.

# DIFFERENT LETTERING STYLES

Often you will find that when using the same lettering style for large compositions it can be hard to make words lie easily on top of each other. This can be due to the space that the ascenders and descenders take up, leaving big areas of blank paper. One exciting way to combat this is to play around with using different lettering styles. You can use bold, chunky letters to partner more ornate script work, or tall, slender letterforms to accompany thick, bold brushwork.

Over the next few pages I have drawn out a selection of alphabets that are a different style to the alphabets that you have been practising so far. These can be created using your brush pens and paintbrush, but can also be drawn with regular markers or felt-tip pens. You do not have to use pressure on your pen to create a thick downstroke or thin upstroke with these letters. You can experiment with your brush pens to see how these fonts come out using different angles, or stick to hard-nib pens that don't flex.

A a B b C c D d E e
F f G g H h I i J K k
L l M m N n O o P p
Q q R r S s T t U u
V v W w X x Y y Z z

A a B b C c D d E e
F f G g H h I i J K k
L l M m N n O o P p
Q q R r S s T t U u
V v W w X x Y y Z z

Aa Bb Cc Dd Ee
Ff Gg Hh Ii Jj Kk
Ll Mm Nn Oo Pp
Qq Rr Ss Tt Uu
Vv Ww Xx Yy Zz

Aa Bb Cc Dd Ee
Ff Gg Hh Ii Jj Kk
Ll Mm Nn Oo Pp
Qq Rr Ss Tt Uu
Vv Ww Xx Yy Zz

# My pen pals

Something that you will discover really quickly on your brush-lettering journey is how lovely the lettering community is. I've had so much support from the people I have met at events and through social media, and I often call on others for advice when I have a project that requires a new technique or material. I love seeing what others are creating and the way in which it expresses their individual personality and style. Everything from the type of pen they are using to the culture in which they are working seems to spill out into their brush-lettering style.

So I asked eight fantastic lettering artists from around the world to send me one of their favourite quotes using the style and materials they love. They were each tasked with addressing an envelope and making their mark on an A4 piece of paper. I also asked one postcard artist to show you how she is using brush pens to connect people around the world. I'm so grateful for their contribution and I'm sure that seeing their work will inspire you to find your own signature style.

May I present to you my fabulous pen pals.

# EVELYN VAN AARLE-ANNEVELDT

Evelyn van Aarle-Anneveldt is a lettering artist from the Netherlands. 'For years I gazed at all the hand-lettered beauty I came across in my daily life, but never thought it was something I could learn. In December 2017 I gifted myself a workbook and my first brush pens, and I've been addicted ever since. I'm passionate about colour blending, a time-consuming but satisfying process, which you can find in all of my work.

Lettering truly is my happy place, where I can reload after a busy day with my three wonderful young daughters.'

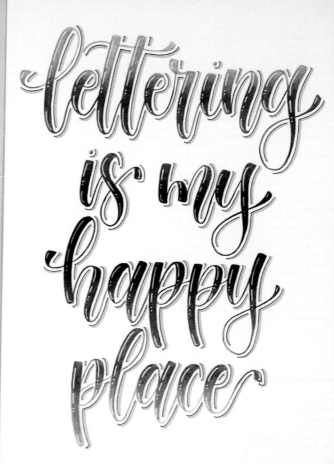

## EVELYN'S TOP TIP

*Don't compare your beginning to someone else's middle! Just take your time to practise and have fun!*

You can find more of Evelyn's work on Instagram: @lienloveslettering

# LIZ HOLDSWORTH

Liz Holdsworth is a lettering artist living in Dublin, Ireland. As a result of being a stay-at-home mum of twins, she wanted a creative outlet that was all her own. Three years ago she enrolled in several online hand-lettering courses and has been studying calligraphy ever since. She is best known for her embossing techniques and bespoke prints. Liz used gold embossing for her pen pal letter and envelope embellishing.

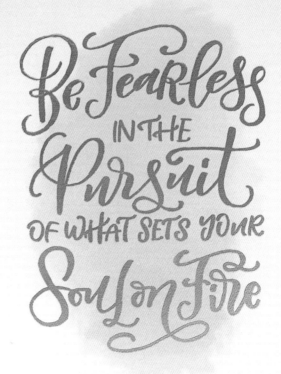

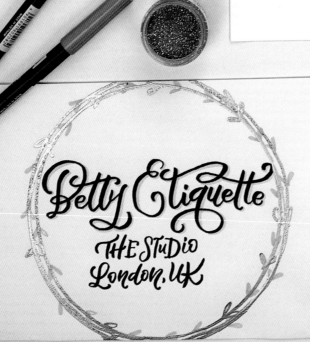

### LIZ'S TOP TIP

*Before embossing anything, make yourself an anti-static pouch! Put a little baby powder in a sock and dab it on whatever surface you emboss to tackle that pesky, lingering powder.*

You can find more of Liz's work on Instagram: @betsysueletters

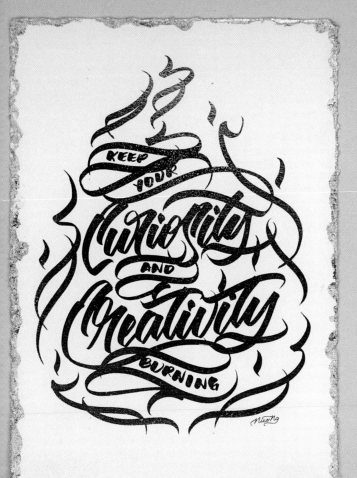

# NICO NG

Nico Ng is a lettering artist from the Philippines. 'My brush-lettering journey started when I decided to purchase my very first brush pen after being inspired by awe-inspiring brush-lettering work on Instagram and on Pinterest. I spent hours every night practising and figuring out the best way to achieve the quality of work I was aiming at. Since that day, brush pens are my favourite lettering tools.

It took me quite a few steps to make this letter. I started by lettering the quote on a sheet of paper using a Tombow ABT brush pen. I transferred it to Photoshop and resized it to prepare for printing, then printed it with a laser toner on a textured white cardstock and applied gold transfer foil. To make the gold edges, I tore the edges of the paper with water for a more natural look, then added the gold using craft gilding glue and some gold leaf. I made the envelope in the same way and then cut and assembled it by hand.'

You can find more of Nico's work on Instagram: @nic_the_

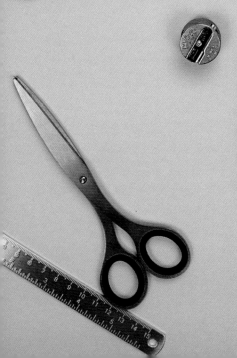

## NICO'S TOP TIP

*My top tip for beginners would be to practise effectively, not just practise by repetition. Always be curious to find ways to improve the quality of your work and be creative to explore different ideas to discover your own style.*

## KELLY DEES

Kelly Dees is a lettering artist who works from her home studio based in Sydney, Australia. She is best known for her freestyle brush lettering and her use of watercolour, metallic inks and glamorous details to make a variety of custom designs and creations. Kelly's lettering business, KD Lettering, has given her a wide variety of professional gigs and projects with companies and people around the world. She loves practising as a modern-day letterer and working on the diversity of projects that lettering provides.

For this art piece, Kelly used pigmented watercolour for the background, with white and gold ink for the letters. She swapped between a water brush pen and a liner brush for her letters and chose a wide flat brush for the background wash. She used her custom-made tassel seal for the finishing touch.

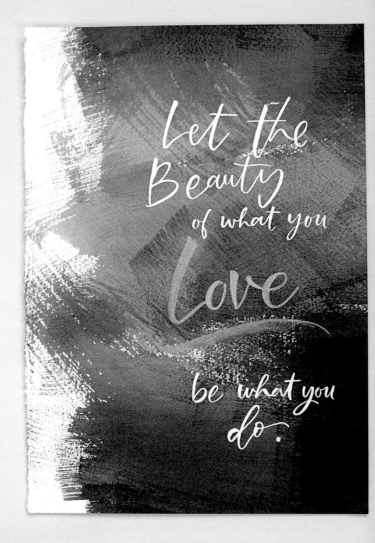

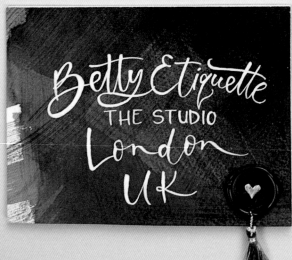

### KELLY'S TOP TIP

*When you first begin, try using brush pens and brushes with short and less flexible tips, then gradually move to longer and more flexible brushes as you gain better control of the letter forms.*

You can find more of Kelly's work on Instagram: @kdlettering

## BEATRIZ'S TOP TIP

*Make sure you carefully consider the size of your brushes and brush pens! They will determine the correct size for your letters, so they don't look stacked or have too much space between them.*

You can find more of Beatriz's work on Instagram: @bealettering

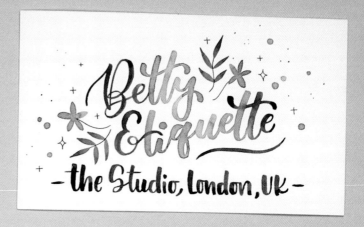

PEN PAL FIVE

## BEATRIZ NÁCHER RODRÍGUEZ

Beatriz is a lettering artist and illustrator from Spain. She works as a civil engineer, but started learning how to draw letters three years ago, as a way to let her imagination run free. Her work can be described as colourful and happy, matching her rather optimistic personality. Bea used watercolours and a size 3 round brush for her pen pal letter, and a bunch of little flowers and leaves scattered around the piece.

109

# PAULA BUENO RODRIGUEZ

'My name is Paula and I'm Spanish but currently live in Ireland. I find great joy in correspondence – snail mail, letters, postcards and stationery are my biggest passion, and it all started about four years ago when I joined an international postcard community. After that I created an Instagram account to document my journey, and I am proud to say we now have a huge community of snail mailers in this social network!'

'I love using brush pens for my postcards and envelopes. They add colour and a special and personal touch to my not-at-all professional but very personal handwriting.

For these postcards I used a range of Tombow ABT brush pens.'

## PAULA'S TOP TIP

*You don't have to save brush lettering for large-scale projects. Postcards are quick and fun to letter, and create memories to keep forever. You can also coordinate the colour of the pen with the stamps to really brighten the recipient's day!*

You can find more of Paula's work on Instagram: @penpaling_paula

# MONICA OCHELTREE

Monica is a lettering artist from California. 'I saw a lettering video in late 2016 and was so mesmerized by the smooth, even strokes. I loved how pretty each letter was, and how just one word could be a work of art. I wasn't sure if I could do it, but I knew for sure that I wanted to try – you'll never know if you never try! I made a New Year's goal to learn to hand letter and have been at it ever since. I have tried so many different styles and techniques and worked with so many different tools and mediums. I have practised for thousands of hours and have been so happy being creative daily. Now, I create art that I never imagined I could! I look back at some of the art when I was first starting out and inevitably, I compare it with my work now. Instantly I smile, knowing that anything I want to do – I can! For this piece I used Canson XL Watercolor paper, Royal Talens Ecoline Watercolor in Indigo, Pale Rose and Cool Grey, and a gold Zebra medium-tip brush pen.

## MONICA'S TOP TIP

*Do not compare yourself to others. You will become discouraged and the joy that comes from being creative will be stolen. Be true to yourself and your own style, and your creative joy will grow in abundance!*

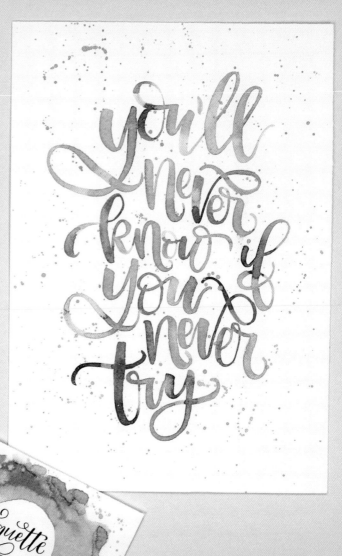

You can find more of Monica's work on Instagram: @handwritten_everything

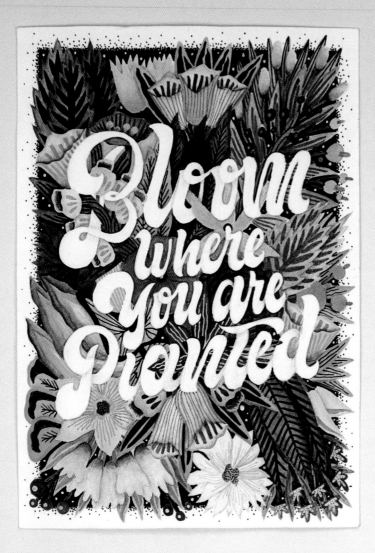

# MACARENA CHOMIK

'My name is Macarena Chomik and I'm a lettering artist based in Argentina. I've always loved lettering and drawing flowers, but I'd never thought about mixing them until about two years ago when I started with my Instagram account.

It's been a rollercoaster since then: trying new things and hating some others, but I finally after lots of practice I've got to the point in which I'm comfortable with the tools I use and like the results. These drawings were created using watercolours and water brushes, Tombow pens, Sharpie markers and embossing pens and powders.'

You can find more of Macarena's work on Instagram: @mletteringlover

## MACARENA'S TOP TIP

*Experiment with new materials and paper colours to see what this does to your work. The most important thing though is to keep practising and don't give up, because practice really does make perfect!*

# Trying new techniques

Once you've started to define your own lettering style and you feel good about using a range of pens and brushes, you're ready to experiment with some new materials. In this chapter, we'll take a look at a few ideas for techniques you could use to create something unique for yourself, your family or your friends, from personalized gifts to designing cards that are little works of art. There are plenty of ideas in Chapter 11 for putting your new techniques into practice. But first, let's explore some of your options.

# WHITE AND METALLIC
# PENS AND INKS

Right then, it's time to get a little sparkly and add a bit of
glamour to your lettering. Writing with white and metallic inks
and pens can take your work to a whole new level and help you
to create fantastic gifts and cards that are the stuff of stationery
dreams. But which of the many different options available will
give you the look you want?

When I first started lettering there were only a few types of
metallic pen on the market that were suitable for brush lettering.
They were the sort that, even though they said 'gold' on the label,
came out a weird sludgy brown colour with a hint of sparkle. But
in the past few years some fantastic pens, paints and inks have
been developed that really do have the twinkly starlit sky look
nailed. So I've narrowed it down to the ones I've been impressed
by, to share with you what they are and what you can achieve
with them. And I've a cheeky trick for how you can create a
brush-lettering look with some of the best metallic and white
fine-tip markers I've found.

 *The best card stock I have found for white
and metallic inks is G.F. Smith Colorplan.
It has a smooth surface with a slight texture,
so looks luxurious but is thick enough to
hold the ink well, and it comes in lots of
beautiful shades. Alternatively, look for a
good-quality coloured card that doesn't
have a shiny finish.*

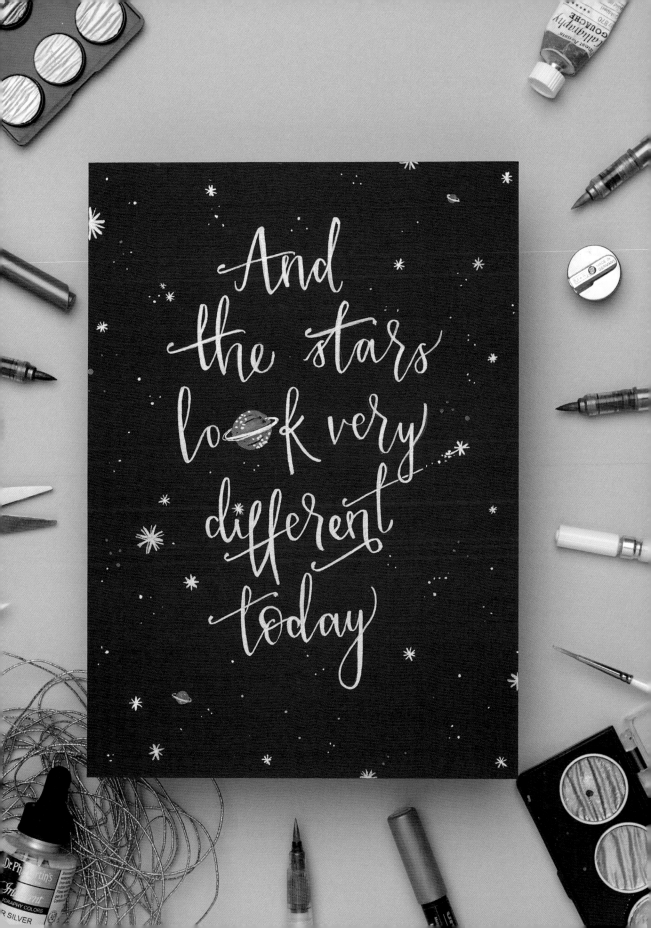

### OPAQUE WHITES

Let's start with white brush lettering. To create easy-read white lettering, particularly large lettering, my favourite white paints and pens are those that are opaque, meaning not able to be seen through. Here are a few options:

**DR PH. MARTIN'S BLEEDPROOF WHITE INK** Easily my favourite choice. Used with a little water to thin it out slightly, it flows really smoothly from a brush or water brush and gives a beautiful opaque finish.

**POSCA BRUSH PEN** The best white brush pen I have found. It has a click button system on the top of the pen that lets through the ink and a synthetic hair tip. It can take a while for the ink to appear when you first start writing and that can be a little frustrating, but when you have got it flowing correctly, it works really well.

**WHITE GOUACHE** As mentioned in Chapter 5, a white gouache will also give you a beautiful matt opaque finish that you can use with fine- and broad-tip paintbrushes and water brushes.

*To avoid expensive mistakes, make sure you read labels carefully to check your pen choice is suitable for the surface you intend to use it on. For example, there are lots of different white markers on the market specifically made for chalk lettering on glass or metal but when put on paper, the ink will sink into the surface.*

*Because you're trying new materials it's easy to forget the basics of your brush-lettering practice. Make sure you are still focusing on your pressure, the angle you're holding your pen and your stroke shapes.*

### BOLD METALLICS

Some metallic colours can be really disappointing or so thin that they just create a wash effect rather than a bold, thick colour. I've been experimenting and here are some of the best I've discovered so far.

COLIRO FINETEC PAINTS  Great for working on dark paper, these light-fast paints have a really amazing shimmer to them that I haven't found anywhere else. Mix them up with a little water and use directly with a paintbrush or water brush until they have a creamy texture, or water them down to use as washes over the top of other lettering. I have used Arabic Gold in my example on page 115, but there is big range of colour tones to pick from.

DR PH. MARTIN'S IRIDESCENT CALLIGRAPHY INKS  These are also easy to use with brushes and they flow really well.

KARIN DECOBRUSH METALLIC PERMANENT MARKERS  These metallic brush pens come in a beautiful range of colours and feel as smooth and soft as the regular Karin BrushmarkerPRO brush markers. The ink may look thin as it goes on the page but as it dries the colour becomes deeper. They are great for projects that will go on display because they are light-fast so won't fade easily.

KURETAKE ZIG FUDEBIYORI AND ZIG WINK OF LUNA BRUSH PENS  These are also really lovely to write with and the ink has a softer, more antique gold look when it is dry.

# FAUX CALLIGRAPHY

Now it's time for that cheeky trick I promised you. If all you have to hand are white or metallic marker pens, rather than ones with brush tips, you can use the faux calligraphy technique to create a cheater's brush-lettering style. And, although I would always prefer that you used a brush tip, this is a good way to make great lettering even with a biro.

*With love*

First, write the word once with a single line, making sure there is a good amount of space between the letters.

*With love*

Then go over the letters to create a second line on the section that would have been the downstroke.

*With love*

Then colour in the gap created by these lines to make the downstroke appear thick. You can use any white or metallic pen for this but my favourite choice is the Uni Posca extra fine 0.7mm bullet tip. Shake it really well each time you start writing with it to make sure the ink flows and the tip is fully covered with the ink.

# COLOUR BLENDING
# AND WASHES

Is your desk covered in pages of black lettering on white paper? If the answer is yes, then it's definitely time to add a little colour to your work. Lots of brush pens are made with water-based ink, so they can be blended with other colours and using water. There are several great colour techniques that I want to show you in this section, but before we even take the cap off a pen, there's one important thing to figure out first. What kind of paper can you use for colour blending?

As we will be adding layers of ink and water to the page to create the effects, we need to use a good-quality, hot-pressed watercolour paper. In my studio I use the Cass Art hot-pressed 300gsm pads, but the own-brand version in your local art supply store will be perfect. If you try to do colour blending on printer paper or in a journal, however, you will find the paper will bleed and may tear easily. Even though they are lettering-based, you need to think of colour-blending techniques as painting with watercolours.

### COLOUR BLENDING WITH A BLENDER PEN
When you went to buy your brush pens, you may have seen a transparent brush pen and wondered what it does: it is a blender pen. Several of the well-known brush pen brands have created these so that you can blend the colours you are using together, enabling you to create new tones in your work. There are two basic ways to use blender pens: directly onto the letters you have drawn, or by using a piece of acetate as a blending tool. For my example, I am using Tombow ABT Dual brush pens.

Be
Bold
Be Strong
Be
Bright

## USING THE BLENDER PEN DIRECTLY ONTO COLOURS

You can simply draw two colours next to each other, then use the blender pen to drag the colour down to blend them together. By using the white of the paper, you can also create gradations in colour as you blend it away from the original marks. Be careful to colour gently to avoid damaging the pen and to prevent making the paper too wet as you blend.

## USING A PIECE OF ACETATE AS A BLENDING TOOL

Take a piece of thick acetate and colour two different areas of colour onto it, so that you can see the ink sitting on the top of the acetate surface. Then use your blender brush to mix and pick up the colour to use directly from the blender pen onto the page. As you write, you will see different tones of the colours appear, giving a dreamy watercolour look to your lettering.

Blending colours on acetate.

You can use a water brush in the same way as the blender brush. As the ink in the pens is water-based, they will blend beautifully when water hits them. Try using two different colour tones on the top and bottom of your letter and a water brush to blend between them. Or build up a range of colours, then run the water brush over them to see what effect this creates. In the example, I have used the Karin

DecoBrush pens; these blend really well and create an aesthetic that people often mistake for watercolour paint.

### COLOUR BLENDING WITH A PAINTBRUSH

Once you know how to hold a round-head paintbrush correctly for brush lettering you can use any kind of coloured paints you have in your toolkit to create blended lettering. Mix watercolour (or gouache) paints together in a palette to create colour blends to use directly onto the paper, just as you would if you were painting a picture. Move between colours by adding more water to your paint and gradually fading from one colour to another.

### CREATING BACKGROUND WASHES

You can also use colour-blending techniques to paint background washes for your lettering. I use this technique often for wedding stationery design and in my own sketchbooks. Simply use pens or paint and a water brush to run the colour across the page, being careful not to overload the paper with water. The paper may bend slightly as it dries, but if you are only covering small areas it should return to its shape once fully dry. Once the background wash has dried, you could use white ink or gouache to letter over the top to give your lettering a new look.

These are just a few ways you can blend colours with your pens and brushes. The more you experiment, the more you will see the endless possibilities to add a pop of colour to your brush lettering.

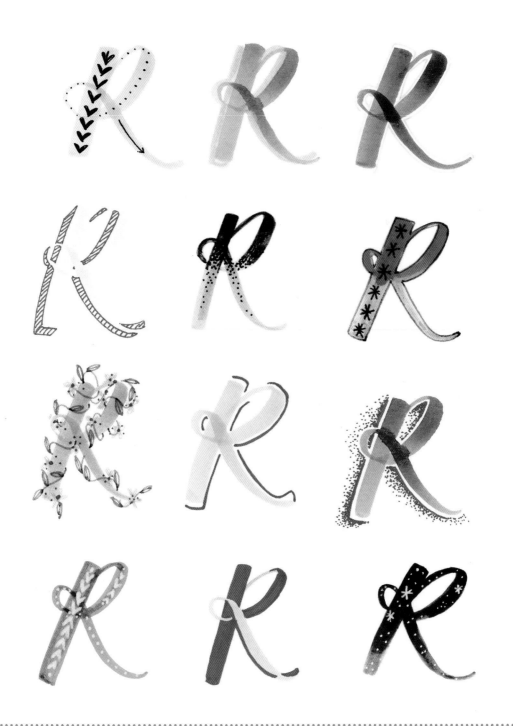

# HEAT EMBOSSING

Heat embossing produces a raised finish to your lettering and it can be used on lots of different surfaces, including card, glass, ceramic and wood. It does require an investment in a little more equipment so I recommend you only try this once you are confident with your basic lettering. You will need an embossing pen (be sure to buy one with a brush tip), a heat gun, a jar of embossing powder and a dry, clean paintbrush.

Decide on the surface you are going to heat emboss your lettering onto – I've chosen a blank notebook. You can either work directly onto your project or use a scrap piece of paper the same size as the area you want to cover to sketch out the design first. If you use a piece of scrap paper, you'll need to transfer your design to your project: use a pencil to scribble on the back of the paper to cover the lines you have drawn, then flip the paper over so your original sketch is showing and place this on your project surface; carefully draw over your sketch lines to leave a faint template for you to work on.

Using an embossing pen with a brush tip (I used the Tsukineko Emboss Dual pen for my design), trace over your design carefully and make sure all the pencil strokes are covered.

Trace your design with an embossing pen.

Sprinkle embossing powder onto design.

Take a piece of paper larger than the surface you are embossing, fold it in half then unfold it and place the item to be embossed onto it. Generously sprinkle your chosen colour of embossing powder all over the pen lines you have drawn. Tap off the excess onto the folded paper underneath your work and carefully pour it back into the pot to use another day. If you can see any loose powder on the page surrounding your letters, rather than on the letters themselves, use a dry, clean paintbrush to remove it. Alternatively, you can also use an anti-static pouch to gently remove loose bits of embossing powder. For a top tip on how to make one of these, see Liz Holdsworth's advice on page 106.

Now it's time to make the magic happen. Pick up your heat gun and hold it 2.5–4cm (1–1$^1$/$_2$in) away from the surface, and slowly move it across the design as you see the powder change and rise slightly. And there you have it, your lettering looks really professional and you've made a unique, personalized gift for someone you adore. Hurrah!

You can also use this process on glasses, vases, mugs and picture frames, but always make sure the item is really clean before you start so the powder doesn't stick to any residue, and remove any extra dust from around the words and inside the letters to make the finish look really professional.

I always get asked if embossed lettering made this way is waterproof. Although curing the powder with the heat gun does make it really hard-wearing, it will still come off slowly in a dishwasher or with regular hand washing. So it is best used for decorative projects only on glass or ceramic, but it is perfect for notebooks and lettering designs on card.

Fix the embossing powder using the heat gun.

you
belong
right here

# LETTERING ON FABRIC

Adding lettering to an item of clothing or a piece of homeware is a great way to personalize a gift. But working on fabric can be really hard, even with the vast range of fabric pens on the market. I have tested several brands and most of them made the lettering bleed, leaving a really unclean look to the design. The best pen I have found for lettering straight onto fabric is the Posca brush pen, which when fixed with an iron can be washed at low temperatures.

I also love using the Derwent Inktense paints and pencils on fabric as because they are ink-based, they are permanent without needing to be heat-fixed. You can apply the paints directly, as you have learnt in the previous chapters, or use a faux calligraphy technique with the pencils and spread the colour with a paintbrush and water. Always try to use natural fabric for lettering projects, as most fabric pens or paint options will work much better on these than synthetic fabrics.

If you are making a banner for a wedding or a piece of wall art that will never need to be washed, you can use a much broader range of product to letter onto fabric, and there are loads of great fabric paints on the market that can be applied with a round-head brush.

Treat your composition on fabric as you would a piece of paper: plan it out on scrap paper first, then transfer the design to the fabric either by working over a light box or copying the layout directly. To sketch out the design, you could use a mark-up pen such as the Pilot FriXion erasable ballpoint pen, which can be erased using a hair dryer once you have finished painting.

Depending on the brushes you have decided to use, you may have to sketch out the lettering in the faux calligraphy style (see page 118) and fill the thick downstrokes in with a paintbrush. Often I have to go over my letters with a second coat to make them stand out.

## LETTERING ON FABRIC USING IRON-ON VINYL

I recently discovered a way in which you can use iron-on vinyl to add lettering to fabric that gives a really clean, professional look and that washes well in the washing machine. Iron-on vinyl is widely available and can be applied to all kinds of different fabric surfaces using a domestic iron to fix it. In my example, I'm adding some lettering to a cushion I have made. I have used Happy Fabric vinyl in a flock finish but it also comes in a matt, glitter and stretch finish. I have followed the maker's instructions for heating, but each brand of vinyl may be slightly different, so please refer to your vinyl manufacturer's guidelines for exact temperatures to use.

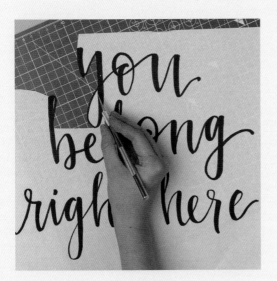

Sketch lettering design onto paper and cut out.

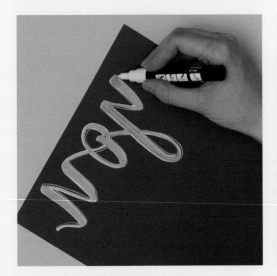
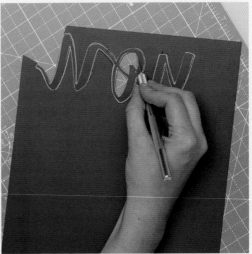

Draw around the paper template onto vinyl and cut out.

Use an iron to transfer the vinyl onto the fabric.

To transfer a lettering design onto the vinyl, first sketch out your lettering design onto paper and carefully cut it out with scissors or a scalpel. Turn your template over so it is facing down onto the back of the vinyl, draw around the lettering design then carefully cut it out.

Flip it over and place the right way up on the surface of the fabric exactly where you want it to go. Place a piece of thick baking parchment over the top and carefully press with an iron at 160°C (this is just above the two dots setting on your iron). (Do make sure the steam setting is turned off as the iron needs to be dry to heat the fabric to the right temperature.)

When cool, carefully peel off the carrier layer to leave the vinyl attached to the fabric. When your item requires washing, turn it inside out and wash at 30°C.

# LETTERING ON GLASS

If you're looking for a new surface for your lettering, then glass is a great one to try. You can add lettering to wine glasses for a party, to mirrors around the home for decoration, to windows for shop displays, or to Christmas decorations. Decide if the lettering will be permanent or if it needs to be able to be washed off after an event.

If you are writing something that you want to remove later, use chalk markers such as the Pentel Wet Erase chalk markers or Marvy Uchida Bistro chalk markers. For long-lasting lettering use permanent pens such as the Sharpie oil-based paint markers or DecoColor oil-based paint markers: these can be oven-baked to fix, then you can use a clear Krylon spray varnish to protect the finish.

For small items, such as pint glasses, leave the decorated glass to dry for 24 hours then carefully place in a cold oven and turn the heat up to 120°C/250°F and set a timer for 30 minutes. When the timer goes, turn off the oven and allow the items to cool fully before removing them. This will help the paint to cure to ensure it stays on the glass for longer, but the glass should only be washed by hand rather than in a dishwasher.

For my sample project, I have chosen to decorate a glass bell jar to make a personalized present for my friends' wedding anniversary using oil-based pens, but the process would be the same whatever the shape or size of the glass project chosen.

First measure out the space that you have to write on and make a paper template to that size. Sketch out your lettering

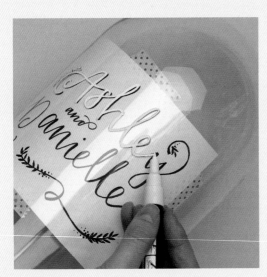

Tracing over lettering guide directly onto glass.

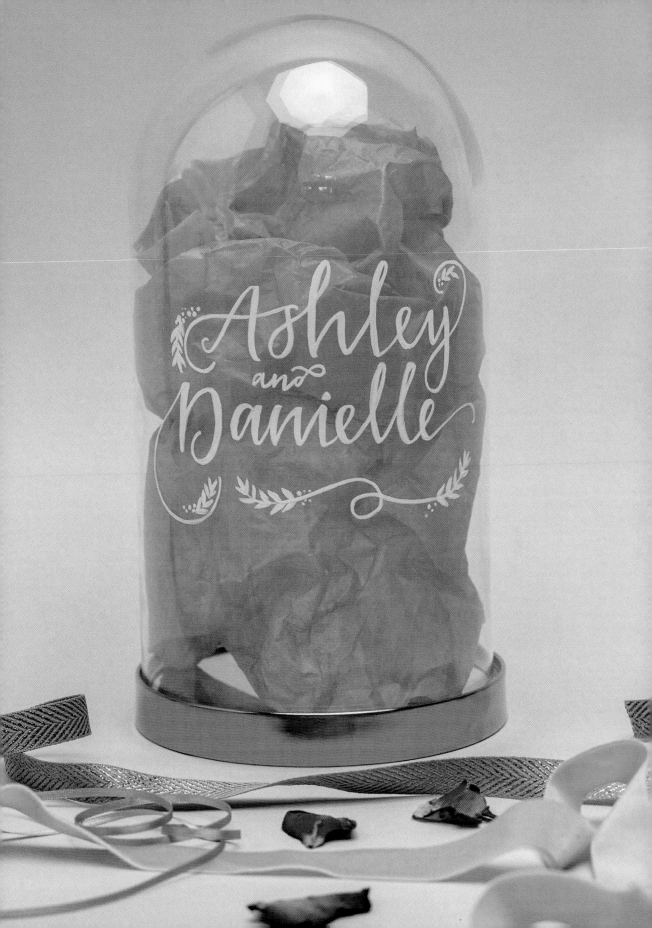

onto your paper template, then use masking tape to place it on the inside of the glass to use as a guide when lettering. (If you are using white marker pens, many only have fine tips so you would need to use the faux calligraphy technique to create the thick downstrokes; keep this in mind as you plan out your design to give yourself enough room.)

Trace over the lettering guide to draw directly onto the glass. When using oil-based pens you need to keep your lettering flowing; try not to go over the lines again too much as it will give you an uneven finish. Leave the painted glass items to dry for 24 hours before handling, then bake as described above for a long-lasting finish.

### LARGE-SCALE GLASS-LETTERING PROJECTS

Sketching out your design with a wax pencil.

If you are creating a window seating plan or a shop window display, you can use the same technique of making a template to stick to the glass to trace off the lettering. For glass projects you need to remove and clean after use, make sure you read the pen instructions carefully to ensure you have not chosen a permanent ink. When you have built up your confidence, you may want to write directly onto the glass without using a guide underneath. A great tool for this is the Stabilo White pencil for film and glass, which you can use to sketch out your lettering onto the glass, then easily wipe away with a damp cloth if you need to change the design. Experiment on an old glass or a small picture frame first to get used to how the pen feels to work with before starting a large-scale project.

# LETTERING ON ENVELOPES

By now, you have all the skills you need to turn an extremely everyday item into a little work of art to pop into the post. Envelopes are a brilliant way to share your skills with others and to experiment with the techniques you have learnt, and to get in some really great composition practice.

Not only will a decorated envelope brighten the recipient's day, but it will also make your letter stand out in a pile, and that once helped me to secure an oversubscribed internship!

There are only two rules for lettering on envelopes: the postal staff have got to be able to read it and the ink shouldn't run if the letter gets rained on. Apart from that, you can use all the skills and equipment you have learnt about so far to create your own beautiful designs to suit the person or the occasion.

Here are six layout ideas for inspiration, and over the page you can see some examples of how they look when they come to life.

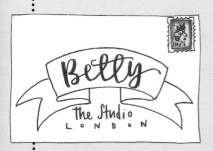

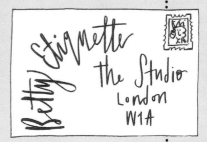

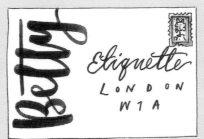
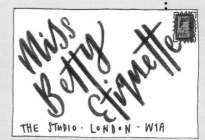

I've been decorating envelopes since I was at school, sending letters to my friends containing the name of my latest one true love or revealing my outfit for the school disco. But it still brings me an immense amount of joy to turn a plain envelope into a little work of art. When you are designing your layout, really try to think about the personality of the recipient, or your reason for writing. Let it reveal a little about the news that is hidden inside.

Columbo
L.A.P.D.
100 WEST 1st
LOS A
CA

Adrian Monk
PINE STREET
Pacific Heights
SAN FRANCISCO

Mapp
&
Lucia
Lamb House
Rye
East
Sussex

Ms.
Nancy
Drew
DREW
RIVER
ONEI
443

Mr
Sherlock
Holmes
221B Baker Street
London
NW1

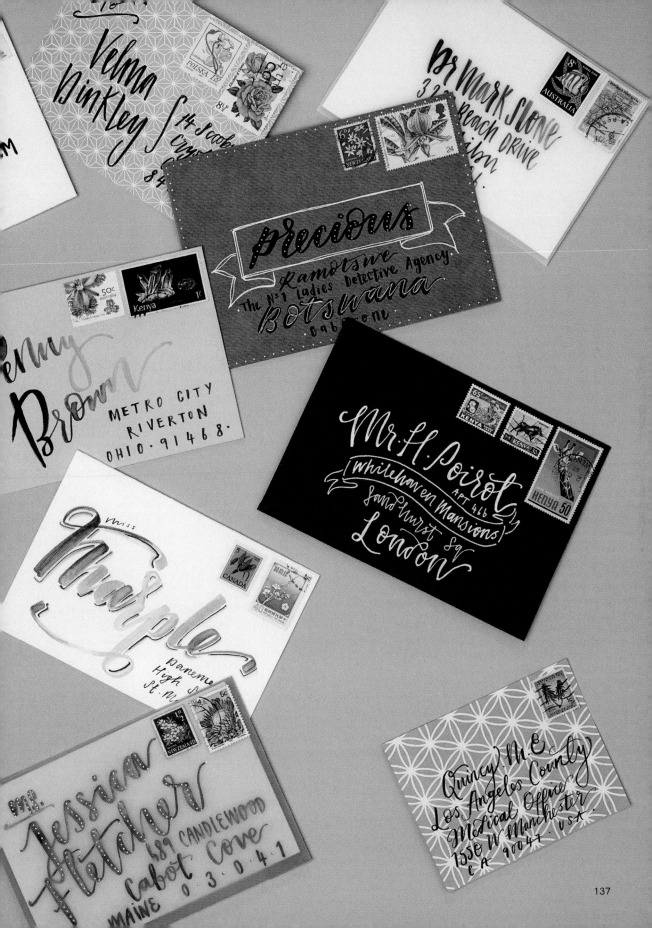

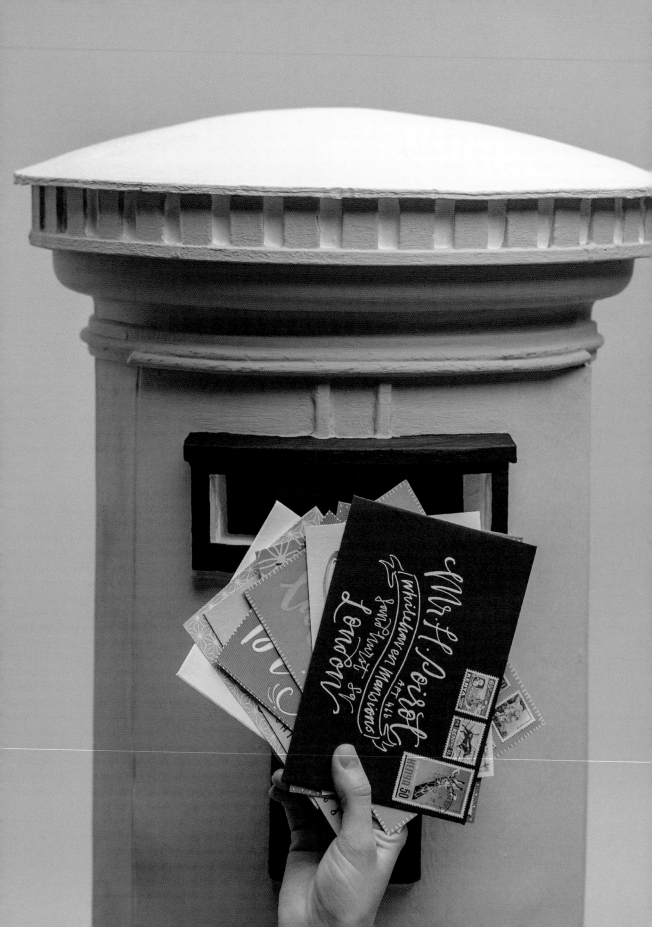

To lay out lettering on an envelope, follow the same composition process that you would use for a piece of wall art. If the envelope is made from a light-coloured paper, then you can use guidelines underneath it (and a light box if you have one). For dark paper, use a pencil or soapstone pencil to draw direct lines onto the envelope. If you are planning on writing large sets of envelopes that need to have a uniform look, for a wedding for example, you may want to invest in a laser level. To use a laser level, set up your workspace with your envelope in front of you, place a masking tape strip around the envelope and mark out where each line will go to the left-hand and right-hand sides of the tape. You can then use this as a guide for the laser line each time you replace the envelope in the masking tape space.

- Always check where your stamp will go first before you create your composition to make sure there is room for it.
- Don't stick your stamp onto the envelope until you have finished lettering, as you will have wasted a stamp if you get the lettering wrong.
- If you use gouache, mix a few drops of gum arabic into the paint to help to keep it from running or smudging in the post.
- Add wax seals, stickers, metallic paint and illustrations to your envelopes to bring them to life.
- Try writing the names on a curve to give the address a different dynamic.
- Run some of the letters of the names off the edge of the page to create a contemporary feel to your work.
- Don't limit your lettering to envelopes for cards and letters only – padded envelopes and parcel boxes are also brilliant blank canvases for your brush-lettering skills.

Now let's look at some other ways to squeeze a little brush lettering into your life. Here are a few examples of things I have created for events and gifts to get your imagination flowing.

# Project ideas

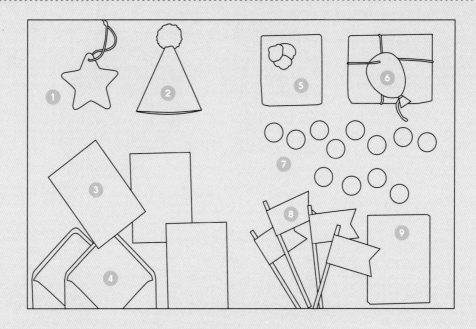

# BIRTHDAY
PREVIOUS PAGE

**1 CERAMIC GIFT TAG** Use blank ceramic shapes with leftover wall paint or tester pots, or try acrylic paint with fixative to create gift tags that can be used as decoration after the birthday.

**2 PARTY HAT** Cut out a simple cardboard cone from a piece of card and decorate with painted lines drawn around it. Write a birthday greeting or child's name in the white gaps and glue a pom-pom on top.

**3 BIRTHDAY CARD** Here are a few ideas for birthday cards. I used a pink Tombow ABT pen and blue watercolour with a paintbrush on 250gsm Bristol board card. I tore different-coloured card to use as the background for the Let's Party card.

**4 ENVELOPE LINERS** Create a liner by drawing round the edge of your envelope as a template (with the flap open) on a piece of A4

paper. Cut out the shape and reduce by 1.5cm (⅝in) on each side so it fits.

**5 WRAPPING PAPER** Either freehand or using pencil guidelines, personalize wrapping paper with lettering running across.

**6 BALLOON TAGS** Cut balloon shapes from dark-coloured card and use white ink or pen for the message.

**7 BADGES** I used a badge-maker for these, but you could cut out thick circles of card and add safety pins to the back. Use pencil to mark out your letter in the centre.

**8 CAKE TOPPER FLAGS** Using a straw or kebab stick as the base, cut a flag shape and glue to the top.

**9 PERSONALIZED PRESENTS** Add a name to a notebook cover to personalize a present or to mark an occasion. This was a Uni Posca white pen on a blank coral notebook.

# WEDDING
NEXT PAGE

**1 BRIDESMAID CARDS** Ask your favourite people to be part of your wedding with little brush-lettered notes in vellum envelopes. I used Tombow ABT pens for these.

**2 CONFETTI CONES** Create personalized confetti cones from 16cm (6¼in) squared paper with lettering across the page. Mix and match paper types and colours with the wedding theme.

**3 BRIDE AND GROOM GLASSES** As a gift or for your own wedding, these glasses would be a great addition to the table. To learn about the embossing method, see page 125.

**4 INVITATIONS** You can use brush lettering in so many ways for wedding invitations. This example is on Cobalt G.F. Smith card with a gouache wash and gold Coliro Finetec watercolour lettering.

**5 RSVP** To show you a different idea, I added vellum paper to the top layer of the RSVP and used the gouache wash and inks used for the invitations underneath. It's always nice to mix and match the textures that appear in your invitation suite.

**6 TABLE NUMBERS** Glass is a great surface for weddings, and I made these table numbers using the method from page 132, but adding an acrylic-paint wash on the back of the glass and writing on the front. You could do the same for a large-scale table plan.

**7 WEDDING CARD** Tell the happy couple how much you adore them with a brush-lettering card. These were created on watercolour paper with Winsor & Newton Ink.

Maid of honour

flower girl

## Details

Accommodation
There's a range of B+B's and

## Rebecca
&
David

Together with their families
invite you to join us to celebrate
3rd June 2019
St. Andrews Church. Ely
3pm Service
Reception @ Wimpole Park

## RSVP

please respond by...
20th March

Name ...........................
Would Love to come ☐  No thanks ☐

## Table 4

Emily Kaine

Will Kaine

Anna Waters

Daniel O'Leary

Lucy Bicker

Jessica Kemp

## Table 3

Grandma

Grandpa

Ruth Clark

Matthew Clark

Auntie Claire

Sinead Flick

you & me

against the world

x

XOXO

hugs & kisses x

i believe in a thing called

love

x

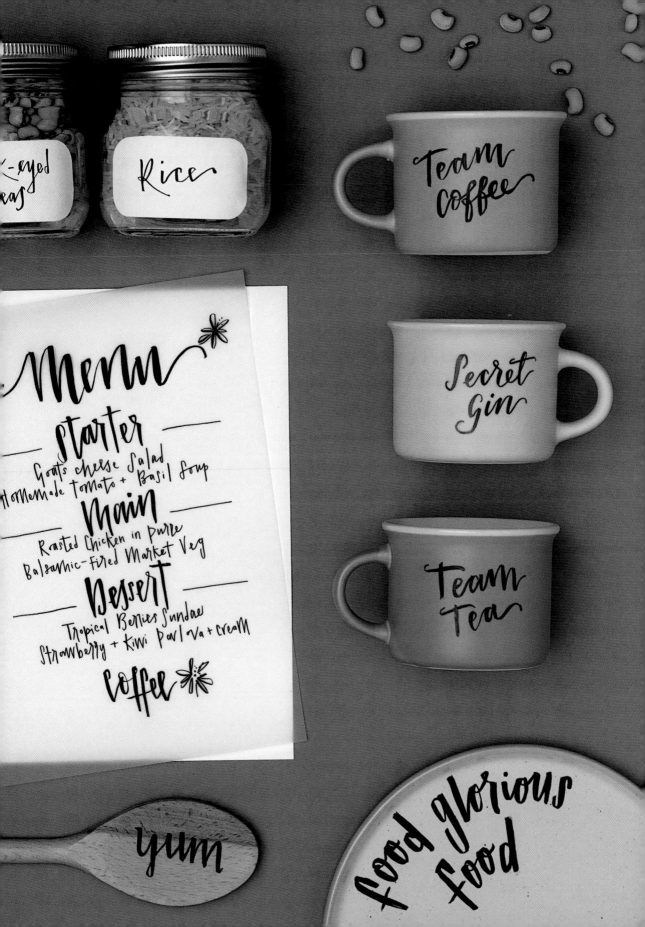

# FOOD

PREVIOUS PAGE

**1 PLACE SETTINGS** Use card, glass, fabric or napkin rings to write the names of your guests on. Ensure the lettering is easy to read from a distance to help people find their place.

**2 PLACE CARDS** You can make place cards to compliment the food you're serving or the colours of your table setting. Here I have experimented with different kinds of card and vellum, and have even painted a pebble to act as a place card.

**3 SPICE JARS** Labelling jars in your cupboard or on display is a great way to show off your lettering skills. Use smaller brush pens like the Tombow Fudenosuke calligraphy pen for smaller labels.

**4 MENU** Mix lettering styles and pens to create a menu for your guests. If you prefer, you could combine a digital font for the detail by printing the main information and simply add brush-lettering titles.

**5 WOODEN SPOON** Adding lettering to wooden utensils is a fun way to create a gift or piece of art for your kitchen. Once written on, the utensil will not be food-safe so can only be used for decoration. I used a Uni Posca pen and spray matt varnish for this project.

**6 MUG** You could use ceramic marker pens or paint or try the embossing method on page 125 to add lettering to mugs. These will usually only be suitable for hand-washing.

**7 EVENT STYLING** Try writing on plates with the date or event or reason for the occasion. To ensure food safety, do check the guidance on the paint or pen you have chosen to use, or simply use as decoration.

# CHRISTMAS

NEXT PAGE

**1 CHRISTMAS CARDS** Christmas is a brilliant time to share your lettering skills. I made these cards by using Ecoline brush pens and writing over the top with a Uni-ball Signo white pen.

**2 BAUBLES** Personalize blank ceramic baubles by painting a base coat of matt emulsion and then add lettering using gouache paint or metallic brush pens. To fix the paint you can use a light matt spray varnish and leave to dry fully. Practise on a sample bauble first to get used to writing on a sphere.

**3 CRACKERS** Buy blank crackers from a hobby store, or make your own and cover them with Christmas cheer, or the names of friends and family who will be sharing a Christmas feast with you. Stick to one colour, or you could try colour blending across the page.

**4 NAUGHTY OR NICE BADGES** Cut out card circles 6cm (just over 3in) in diameter and draw the words 'naughty', 'nice' or 'I tried' onto the circles. I used velvet ribbon to attach to the back and a safety pin backing to turn these into badges. I used watercolour and watercolour card for this example.

**5 GIFT TAGS** I love making gift tags for Christmas presents. I pick solid-coloured wrapping paper and try to add a gift tag and ribbon that brings a pop of colour two it. Try experimenting with different shapes, making paper tassels, layering up the paper and using metallic inks and pens to vary the designs.

Silent NIGHT Holy NIGHT

Noel

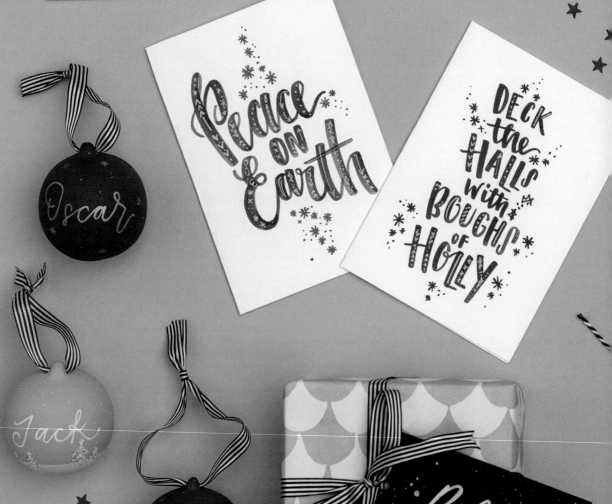

Peace ON Earth

DECK the HALLS with BOUGHS of HOLLY

Oscar

Jack

Violet

Betty

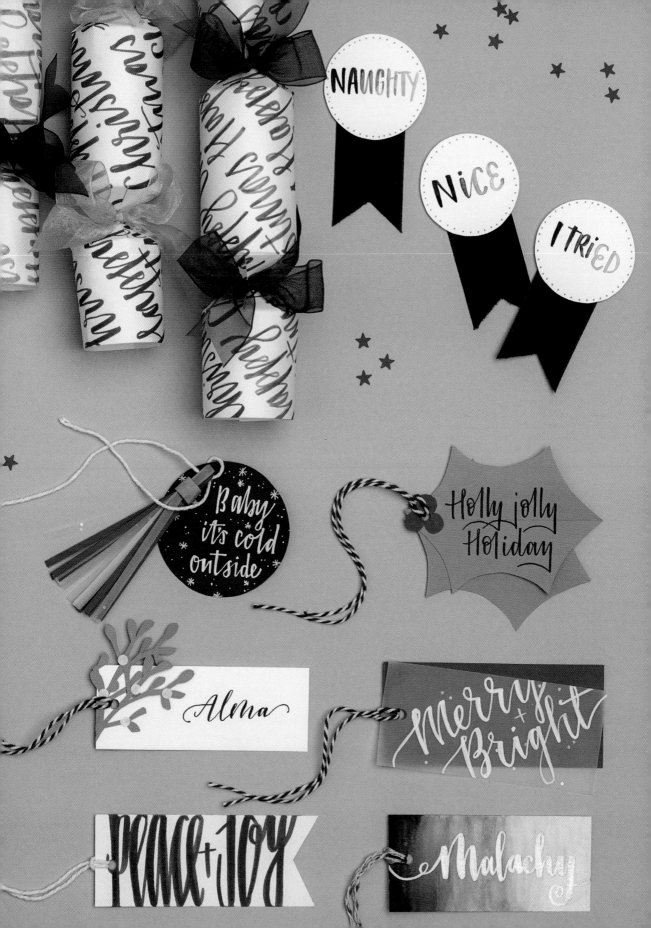

# Troubleshooting

I have gathered together the following questions from those most frequently asked at my workshops, which should help go a long way to provide you with answers to the problems you may face in your brush-lettering practice.

But the biggest bit of advice I can give you is to have patience and be kind to yourself on your brush-lettering learning journey. It's really easy to get disheartened while learning a new creative skill, especially now we have access to millions of pictures of others people's work at our fingertips. Try not to compare your work to that of other artists: it instantly crushes the joy in the process and will stop you from developing your own style. There's no bad mark you can put on the page; it's all brilliant practice, so just shake those doubts out and get lettering!

## WHY CAN'T I KEEP MY PEN/BRUSH AT THE RIGHT ANGLE?

This is the thing that 90 per cent of people at my workshops get frustrated with when first starting out. You have to trick your brain into thinking that you haven't written before and that it is a new piece of equipment you are using. If you were picking up a crochet hook or felting needle for the first time, you'd just follow the instructions as you explored a new skill. But because we can already write, it is harder for us to forget our current writing habits. To help remind you, draw a picture of the pen at 90 degrees at the top of your paper sheet, or set an alarm to beep every 15 minutes of your lettering practice so that you can check the angle of your pen when the alarm rings.

## WHY ARE MY UPSTROKES SO WOBBLY?

This is another common problem for beginners. I'm working on a magic glittery glove that will make it easier, but until then the best way to stop your upstrokes from being wobbly is to practice. You need to build up some muscle memory in your hand to help you to have the strength to control the pen enough to make those lines consistently smooth. It will come, I promise, just hang in there.

## WHY DO MY UPSTROKES LOOK JUST LIKE MY DOWNSTROKES?

If your strokes are all looking the same, it is usually down to two things: working too fast and putting too much pressure on the upstroke. Slow down the pace at which you are working and get practising those upstrokes: you need to make light but confident strokes with very little pressure on the pen to create a fine line. But if you're not applying enough pressure to your downstrokes, they will look the same size as your upstrokes, so don't be afraid to press down on that tip (it's more robust than it looks) to create a big thick line.

## WHY IS MY PAPER GETTING SOGGY AND BREAKING UP WHEN I'M USING INK?

If you are using ink or paints for your brush lettering then you should ideally be using watercolour paper. Basic printer paper or sketchbook paper may be fine for writing with your brush pens, but it won't hold ink well and the ink will leak to the other side of the page. I use Cass Art hot-pressed 300gsm smooth watercolour paper in my studio for the majority of my ink work, but whatever weight and brand you decide to use, check your ink or paint on a spare piece of paper first to make sure it is suitable and that it dries well.

## MY PEN HAS STARTED TO FRAY AT THE END – WHAT IS HAPPENING?

If you notice that the end of your pen is starting to look fuzzy or frayed it is probably because you are using paper that is too rough for it. If you make sure you have smooth practice paper and that you are holding your pen at the right angle, this shouldn't happen. Unfortunately, once a pen has frayed, there's no way to make fine

precise lines with it anymore. But don't throw it away: use it for sketching or composition practice and save the new one you buy for finished projects.

**WHY DO THE TOPS AND BOTTOMS OF MY LETTERS KEEP COMING OUT FLAT AND NOT CURVED LIKE THE EXAMPLES?**
In most cases this is because the pen is slipping back to the angle you normally write with when using a biro or pencil. When the angle of the pen is not at 90 degrees in line with the top of the paper, the brush tip cannot form a smooth shape as it turns. This will come I promise, but for a while you will have to keep consciously moving your pen or brush back into the correct position and to keep a vigilant eye on it. Slowly the muscles in your hand will get used to the new position you need to hold the pen in. Keep looking back to the top of your page to make sure the pen is in line with it as you are working, and remember – it will get easier the more you practise.

**WHY DO MY HANDS KEEP HURTING AFTER I PRACTISE FOR A WHILE?**
Because we don't use handwriting very often in our day-to-day lives these days, sometimes hands can get tired when practising lettering. It reminds me of that feeling I used to get in the school exam hall when I had to write solidly for two hours to try to get all my answers down in time. To prevent this, give yourself short breaks after every 30 minutes, and stretch out your

fingers and massage your hands. If that doesn't help, you might be holding your pen or brush too tightly. Try to loosen your grip slightly to let your fingers recover.

**I CAN'T GET THE 'F' OR 'R' TO LOOK LIKE THE EXAMPLES – WHAT AM I DOING WRONG?**
The alphabets I have created are based on Copperplate calligraphy letterforms. They are cursive and as such are made to flow from one to the other smoothly. The letters 'f' and 'r' are good examples of this as the way you write them enables you to keep a flow to the word you are making. They will get easier with practice, but if they are proving tricky or you don't like the style, get a pencil and see how you normally write your letter 'f' and 'r' and use this as the base for those letters instead. Now try them out with your brush pen and just make sure you keep a thick downstroke and thin upstroke when you write them.

### HOW CAN I STOP GETTING INK ALL OVER MY FINGERS WHILST WRITING?

If you're finding that you're getting ink on your fingers whilst practising, it could be that you are holding your pen or brush too close to the nib or hairs. Try bringing your fingers a couple of centimetres (about an inch) further down the pen or brush. This will also help you to control your mark making more easily, giving you more room to manipulate the brush or pen in your hand. If you're using a paintbrush, it could be that you're dipping your brush too far into the inkpot each time, which means it will have ink on the handle that can accidentally transfer to your hand and paper. Try to dip more gently to avoid excess ink on your brush.

### WHY DOESN'T MY WATER BRUSH GIVE OUT A CONSISTENT FLOW OF INK/PAINT?

These brushes can be tricky beasts to get the hang of when you first start using them. If you are filling them with water and using them with a paint palette, you need to make sure you have enough water coming through the bristles to mix the paint to a flowing consistency. If the paint is too dry or the brush doesn't have enough water flowing through it, the letters you are writing may come out patchy. Sometimes this can accidentally create a lovely organic feel to your lettering, but if you are aiming for solid blocks of ink or colour, you need to make sure you're squeezing enough ink or water through your brush to create this.

### HOW CAN I STOP RUNNING OUT OF SPACE AND AVOID HAVING TO CRAM LETTERS TOGETHER ON MY PAGE?

There is nothing more frustrating than running out of space for the final word on your page. It all comes down to composition and how to plan out your lettering design. As you gain confidence in your lettering this will become easier and you will find you can judge the space needed for words more naturally. When you're starting out, it's key to plan out your projects before you begin. Although you might be really eager to get the project done, it always pays off in the long run to sketch out your design in pencil first, and where possible to do a mock-up in the final pen or brush you are going to use. Go back to Chapter 8, page 98, to read up on my tips for composition for extra help.

TEMPLATES

# SUPPLIERS

## UK

**CASS ART**
66–67 Colebrooke Row
London
N1 8AB
www.cassart.co.uk

**LONDON GRAPHICS CENTRE**
16–18 Shelton St
London
WC2H 9JL
www.londongraphics.co.uk

**L. CORNELISSEN & SON**
105 Great Russell St
London
WC1B 3RY
www.cornelissen.com

**GREAT ART**
41–49 Kingsland Road
London
E2 8AG
www.greatart.co.uk

**FRED ALDOUS LTD**
37 Lever St
Manchester
M1 1LW
www.fredaldous.co.uk

**RENNIES ARTS & CRAFTS**
63 Bold St
Liverpool
L1 4EZ
renniesartsandcrafts.co.uk

**ONLINE STORES ONLY**
www.scribblers.co.uk
www.stonegift.com
www.cultpens.com

## EUROPE

**LE GÉANT DES BEAUX-ARTS**
15 rue Vergniaud
75013 Paris
France
www.geant-beaux-arts.fr

**ONLINE STORES**
Germany – www.j-stuff.de

**Poland**  www.calligrafun.com
**Italy**  www.calligraphystore.it
**The Netherlands**  www.penstore.nl
**The Netherlands**  www.splendith.nl

## USA

**BLICK ART MATERIALS**
Stores throughout the US including:

- 1574 N Kingsbury Street
  Chicago, IL 60642
- 7301 West Beverly Boulevard
  Los Angeles, CA 90036
- 6250 South Dixie Hwy
  Miami, FL 33143
- 237 West 23rd Street
  New York City, NY 10011
www.dickblick.com

**JET PENS**
www.jetpens.com

**JOHN NEAL BOOKS**
1833 Spring Garden Street
First Floor
Greensboro, NC 27403
www.johnnealbooks.com

**PAPER AND INK ARTS**
113 Graylynn Drive
Nashville, TN 37214
www.paperinkarts.com

**LETTERING DAILY**
www.lettering-daily.com

**ALL ART SUPPLIES**
Art Supplies Wholesale
4 Enon Street
North Beverly, MA 01915
www.allartsupplies.com

## CANADA

**AVENUE DES ARTS**
328a Ave. Victoria
Westmount, Quebec
H3Z 2M8
www.avenuedesarts.ca

**CURRY'S ART STORE**
1153 Queen Street West
Toronto, Ontario
M6J 1J4
www.currys.com

**OPUS ART SUPPLIES**
Stores throughout British Columbia
including:

- 512 Herald Street
  Victoria, BC, V8W 1S6
- 555 West Hastings Street
  Vancouver
  BC V6B 4N6
- 95 - 5501 204 St
  Langley Mall, Langley
  BC V3A 5N8
opusartsupplies.com

**DESERRES ART STORES**
www.deserres.ca
Stores throughout Canada

**STUDIO SIX ART SUPPLIES**
Markham, Ontario
L3R 0G9
www.studio-six.com

## AUSTRALIA

**MOORABBIN SUPER CENTRE**
444 Warrigal Rd
Moorabbin VIC 3189
www.artshedonline.com.au

**THE SYDNEY ART STORE**
940 Bourke St
Zetland, NSW 2017
www.thesydneyartstore.com.au

**ECKERSLEY'S ART & CRAFT**
Stores throughout Australia including:

- 18 King William Street
  Adelaide SA 5000
- Level 5, Westfield
  Bondi Junction NSW 2022
- 73 Tudor St, Hamilton
  Newcastle NSW 2303
www.eckersleys.com.au

# ABOUT THE AUTHOR

Rebecca Cahill Roots has been putting pen to paper since childhood. Her passion for lettering began with thank-you cards around the family kitchen table and has since developed into an award-winning creative business, Betty Etiquette.

From her home studio Rebecca creates hand-lettering designs for magazine editorials, weddings, branding and her own stationery range. Alongside applying her calligraphy techniques to stationery and private commissions, Rebecca teaches modern calligraphy and brush-lettering workshops, from private tuition for celebrity brides-to-be to large-scale corporate events. Her inky adventures have taken her to magical venues including Liberty London and the Victoria and Albert Museum.

Rebecca lives with her family in south-east London and can usually be found in ink-stained dungarees with an emergency biscuit tucked in her pocket. She is a passionate advocate for handmade craft and small business in Great Britain.

Follow her inky adventures at www.bettyetiquette.co.uk | @bettyetiquette

# ACKNOWLEDGEMENTS

It takes a whole bunch of people behind the scenes to pull together a book like this, and I'm lucky enough to have had a really brilliant bunch! Thank you to the team at Pavilion Books for leading me through the writing process again. My editor Nicola Newman has given me invaluable support and guidance to shape my ideas into page-worthy pen marks. Many thanks to Tokiko Morishima and Sally Bond for your beautiful design work and the very patient Michael Wicks for your photography wizardry.

Great thanks go to the seriously talented artist contributors: Nico Ng, Paula Bueno, Beatriz Nacher Rodriguez, Liz Holdsworth, Evelyn van Aarle-Anneveldt, Kelly Dees, Monica Ocheltree and Macarena Chomik. Thank you so much for your beautiful contributions and for trusting me with your divine lettering.

To my long-suffering family and friends who have had to put up with me during this process. Caitlin, Fred and Patrick, your incredible families are the best messy bundle of love I could wish to

be part of. And thank you to my parents and Mum-in-love-and-law, Catherine, for, well, everything. Now I have a little one of my own, I finally get it and I couldn't be more grateful that you did all this hard work/parent juggle for me.

My incredible friends, Silvie, Dani, Tania, Rosie and Dan, are the best of people. They're so supportive, I think I should rent them out to others going through small business challenges, it seems selfish to keep them to myself. Thank you wonderful humans.

And a massive thank you to everyone that has supported Betty Etiquette, whether it be through attending a workshop, purchasing a product or simply helping to spread the word. I'm so grateful for the community that has come along with me on my journey so far.

But most of all thank you to my loves, David and Little R. Let's build cardboard rockets, pillow mudisuppers and do bundles escapes together forever. You're my heart just walking around out there on one tall and one tiny set of legs.

# INDEX